PAINTING ANIMALS
Step by Step

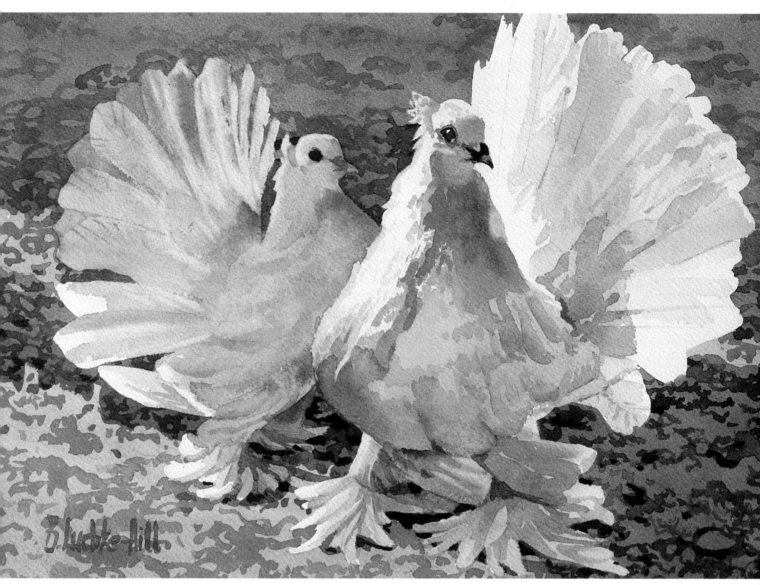

Courting, 9″ × 12″, watercolor

PAINTING ANIMALS
Step by Step

Barbara Luebke-Hill

NORTH
LIGHT
BOOKS

CINCINNATI, OHIO

Barbara Luebke-Hill was born and raised in Kansas. She graduated from Colorado State University in Ft. Collins and continued her art studies at Diablo Valley College in Pleasant Hill, California. She has also studied with many professional watercolorists across the country and has taught adult classes in watercolor, including Jade Fon's Asilomar Watercolor Workshop in Monterey, California. She has expanded her own abilities by working in oil as well as watercolor.

Barbara's love of animals began in her early childhood years on her grandparents' farm in rural Kansas. Her love of the outdoors, nature and animals is an integral part of her paintings.

"My goal in painting is to portray to the viewer those special moments in an animal's life—the time, the color and light, the feeling I have for it—then express that feeling in a creative, painterly way."

Barbara has participated in many one-person and group shows. These include the American Watercolor Society Annual, the California Exposition Art Show, the Society of Western Artists Show, De Young Museum, San Francisco, the National Academy of Western Art, and the Gilcrease Museum Annual Miniature Show. She has received numerous awards through the years.

Barbara's work has been featured in articles in *Southwest Art* magazine and *American Artist* magazine. Her work is also reproduced in *The Artist's Guide to Using Color* by Wendon Blake and *Splash 2*, a book featuring watercolorists and their work.

Barbara resides in Tucson, Arizona, with her watercolorist husband, Tom Hill, author of *The Watercolorist's Complete Guide to Color*.

Painting Animals Step by Step. Copyright © 1992 by Barbara Luebke-Hill. Printed and bound in Hong Kong. All rights reserved. No part of this book may be reproduced in any form or by any electronic or mechanical means including information storage and retrieval systems without permission in writing from the publisher, except by a reviewer, who may quote brief passages in a review. Published by North Light Books, an imprint of F&W Publications, Inc., 1507 Dana Avenue, Cincinnati, Ohio 45207. 1-800-289-0963. First edition.

96 95 94 93 92 5 4 3 2 1

Library of Congress Cataloging-in-Publication Data

Luebke-Hill, Barbara.
 Painting animals step by step / Barbara Luebke-Hill.
 p. cm.
 ISBN 0-89134-459-4
 1. Animals in art. 2. Painting—Technique. I. Title.
ND1380.L84 1992
751.4—dc20 92-2360
 CIP
 r92

Edited by Greg Albert and Rachel Wolf
Designed by Sandy Conopeotis

TO TOM

ACKNOWLEDGMENTS

My special thanks go out to Greg Albert, Senior Editor for North Light Books. He gave me the opportunity to do this work and I am forever grateful. Greg has a wonderful way with words of encouragement. He knew just how to get me through my low, not-so-good spots and how to spur me on to better and better effort. Those gentle nudges were timed just right.

I also want to say thanks and express my appreciation to Rachel Wolf and all the rest at North Light Books who helped get this book from the idea stage to final production.

Thanks are also owed to my husband, Tom, whose daily encouragement, help with problems, advice and photographic expertise made my task go a lot more smoothly. Those "you can do its" coming over my shoulder have been greatly valued. I've especially appreciated Tom's help in taking over some of the household chores in order to give me more working time.

I want to thank all of the people I approached who let me use their pets as models in my book. Also, I'd like to extend my thanks to the Budweiser people for the opportunity to use their Clydesdales, and to the persons managing the University of Arizona's dairy herd.

Demonstrations

These fifteen step-by-step demonstrations show you how to create beautiful animal paintings in watercolor and oils.

Introduction

Painting animals can be one of the most pleasurable experiences available to an artist. If you have an underlying love of animals, your inspiration and fun will come easily. Any animal, no matter how ordinary, can be painted in an interesting and exciting way. I once read that an artist can paint a lifetime within three miles of his home and I believe it. All of the animals used for subject matter in this book were found right in my own locale. Everyone in the world has the same opportunity, as we all live with animals.

Anyone and everyone can be an artist, although some people have more ability and drive than others. Of course, it helps to have talent, but talent can be developed. Really, it doesn't matter how wonderful or fantastic the final product becomes—what's important is the fact that *you did it*. That makes it all worthwhile. Someone else can show you how they do something, but in the end, you teach yourself by doing it. You can watch me or anyone else paint and it won't help you improve until you are ready to work at it yourself. That's why your drive and motivation are important. You will be starting out with some degree of ability. The challenge is to improve. All it takes is a bit of interest and hard work. Anyone can do it!

The purpose of this book is to show my method of painting animals using watercolor and oil. Many artists paint animals photographically and with more technical information, but for me, I want to express myself in a more interpretive and creative way. I also hope to inspire you to "see" your pets and the domestic animals around you in a more original and imaginative way. I hope to stimulate you to run for your pencils and brushes and give it a try, too. This can be a starting point for any artist or beginning painter and can be taken to who knows where. You will develop your own method of expression and it will be entirely different from mine. Therein lies personal expression. No two people will paint the same—that's the beauty of it. You

will put down your own impressions and the results will be "you." There is nothing in the whole world that is so totally "yours."

Most animals have many similarities and parts in common. They have more parts in common than they have parts that are completely different. Once you learn the location and names of the major parts, that knowledge can be applied to all of the animals. You will find that the bones and muscles differ mainly in size and shape. I will also lightly touch on some behavioral aspects of the different animals. It is helpful to know ahead of time what behavior to watch for.

I can't say enough about the importance of looking at good art and studying other artists' methods. I have several favorite animal artists. One is Heinrich Von Zugel, a German artist who died in 1941. His favorite subjects were cows and sheep, though he also painted horses, burros, goats and dogs. His work has been a great inspiration to me. I treasure my book of reproductions of his great work. I was fortunate enough to see twenty of his originals during a trip to Germany. Another artist whom I admire is Bob Kuhn, a present-day painter who works mainly in wildlife. He is a sensitive artist, has a lovely color sense, and also has great designs and compositions. I'm always anxious to see what Bob will come up with for the next show; I know it will be good and that I'll learn something from it. Now let's start our exploration!

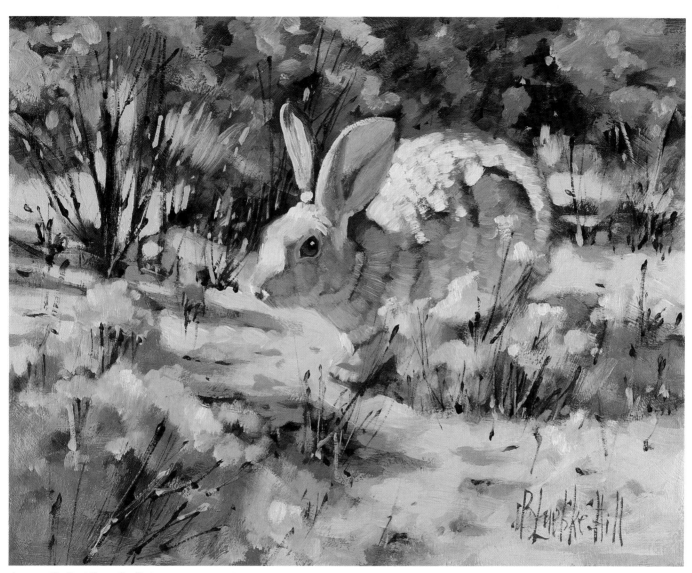

Autumn Frolic, 11″×14″, oil

Finding the Subjects

Use these great ideas to enlarge your repertoire of animal subjects

Animal subjects and models are everywhere. Talking about them and observing them will stimulate you to give painting them a try. So, to jump right in, let's start at home. It's much easier to paint an animal you are familiar with than one you see only occasionally.

Around the House

If you are a somewhat timid painter, or a beginner, you might feel more comfortable starting at home with your own or your neighbor's pet. Become familiar with its personality, behavior and attitudes. What kind of poses does it like, what movements does it make, what does it do the majority of the time?

My cat will sit on the wall for hours, in a watchful pose, taking in the activity in the desert. She also sleeps a great deal of the time. Those are two different types of poses that would make great painting subjects. Perhaps your dog has a restful guard activity that takes up much of his time. These are perfect opportunities to paint your pet.

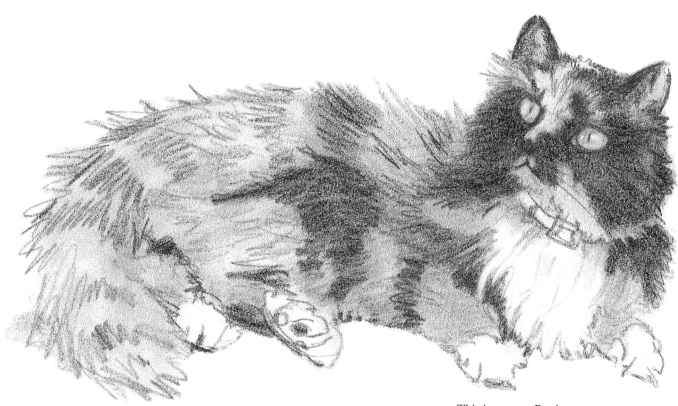

This is our cat, Patches.

It's easy to catch a pet repeating poses, so it's not hard to work your painting up to a finish, working a little each day as you have the time. It's more practical, if you are painting in watercolor, to work quickly to get as much down in one session as you can. Painting in oil may slow you down a bit, but if you work alla prima, you can accomplish about the same degree of finish in the same amount of time.

Try to capture the animal in some type of normal behavior, not something that is strange for that animal. You may not realize it, but you do notice forms, attitudes and behaviors in your pets and other familiar animals. This subconscious knowledge comes forward when you put something down in a drawing or painting. You know the subject so well that you can recognize when something isn't quite right. You may develop an uneasy awareness about a particular part of your drawing. When you get that bothersome feeling, take note. Go back over that particular part. Redraw it over and over again until you are happy with the results. Then transfer your new drawing to your canvas or watercolor paper. It's even easier to see the errors when someone else has painted your favorite animal than it is when you yourself did the painting.

I did a painting of our cat, Patches, in three to four days. She has a habit of sleeping on the end of our bed at a certain time each day. When I decided to paint her in oil, I spread some newspaper on the floor in front of the bed and started in. I sketched her gesture first, which was one of staring out the window at the birds. She would stay on the bed about an hour, so this was my painting time. If she changed her position, I would wait a few minutes, then gently coax her back into her original position. She was a good model. When she had had enough "bedtime," I accepted that, and we repeated the procedure for the next several days. It was always about the same time of day so the lighting was consistent.

Fit your painting schedule to your pet's schedule and you both will avoid frustration. This might be inconvenient for you unless you are at home all day with your pet. On the other hand, if you are out of the house all day and have only weekends or evenings to paint, you'll probably find that your pet has missed you and will want to be in your company, as that is precious time for him also.

If you don't own a pet, perhaps a neighbor, friend or relative does. You'll be surprised how cooperative

people become when you mention you'd like to paint their pet. It's been my experience that people will bend over backward to help you get the information needed.

My neighbor has a new, fully grown dog with a skittish personality and the dog hasn't warmed to me yet. I spend a lot of time on my hands and knees trying to befriend him. I hope to succeed one day. It takes patience. I know this dog just needs to be reassured that I am okay and my intentions are good.

Check the Backyard

Your own backyard may have the very subject matter you need; check out the possibilities there. Rabbits (cottontail and jackrabbit) are almost everywhere except in cities. If you are a city dweller, it may take a journey to the outskirts of town to find rabbits. They can become somewhat tame if you make a practice of feeding them. At my home they sit outside waiting for a handout every morning. Perhaps a friend has a pet rabbit. If not, call your local 4-H group. Children all over the country have projects of raising rabbits and other animals. The 4-H is a good source close by you with numerous potential animal subjects. It's also fun to attend the county or state fair and visit the animals. I visited our local county fair and became acquainted with several rabbit owners. From there it was easy. You might be surprised at the assortment of animals on view at a fair.

It's not hard to attract our feathered friends. All you need is a little food of some sort, and you will have plenty of subjects at your disposal. At times, I use what is called chicken scratch, which is good for the larger birds like quail and doves, the passerines, plus the rabbits, too. If you want to attract the smaller birds, use wild bird seed; it has all sorts of goodies, including sunflower seeds. Sunflower seeds are a favorite of birds with a finch-type bill. Here in Tucson, we have available to us a quail block. It's a hard block of compacted seed about the size of a salt block. All of the birds and rabbits love it.

Get yourself situated comfortably and let them come to you. They really don't need much coaxing, and they are easy to work with.

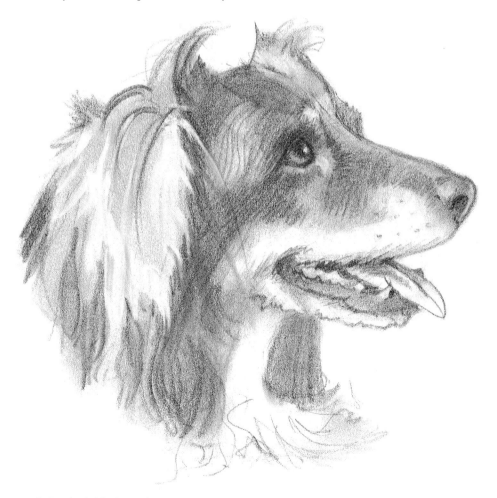

I sketched this dog at home.

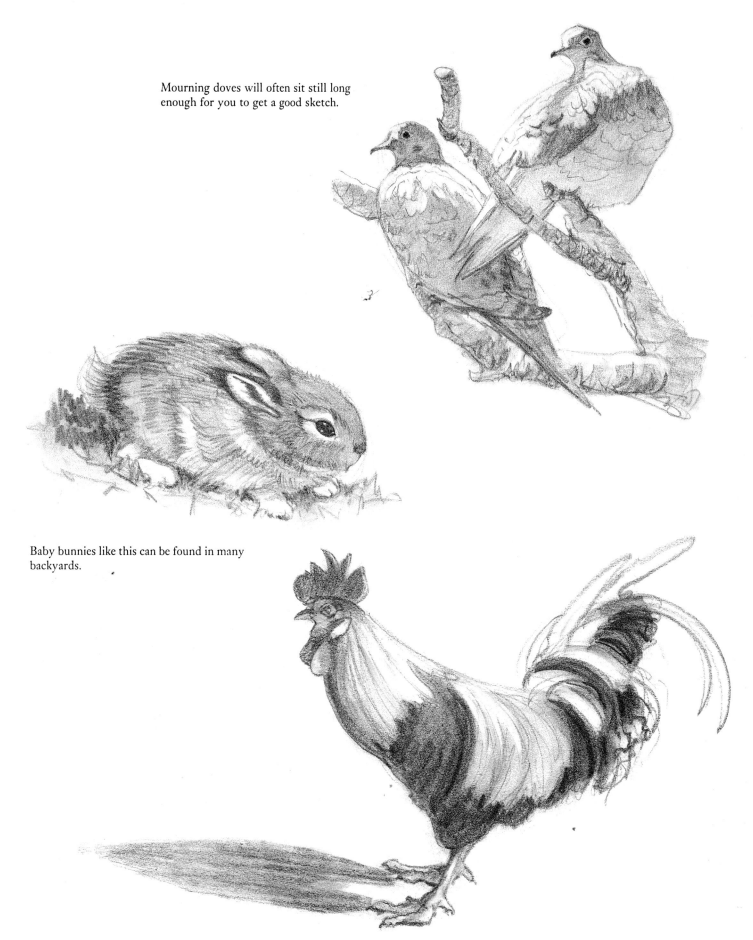

Mourning doves will often sit still long enough for you to get a good sketch.

Baby bunnies like this can be found in many backyards.

You may even find a rooster strutting around a neighbor's yard.

You may find chickens in some neighboring backyards, but most likely you'll need to make a trip to a farm. Some people keep them as pets for yard cleanup (bugs and worms) and for an occasional fresh egg. Look for roosters. They usually are more colorful and have fancier plumage and combs. Anywhere you find them, they are fun to sketch and paint. There are so many varieties, colors and shapes—always something different and interesting. Watching their behavior is entertainment in itself. Some remind me of little clowns running around. Their movements are almost always unpredictable, but that's part of their charm and character. Their walk and their head movements are usually jerky. If you can capture that jerkiness in a chicken painting and the waddle in a duck or goose painting, you've got it made. I'll describe these characteristics in later chapters.

Don't forget the wee beasties all about you. I've painted grasshoppers, bees and beetles, but never butterflies. Maybe I'm missing a great opportunity!

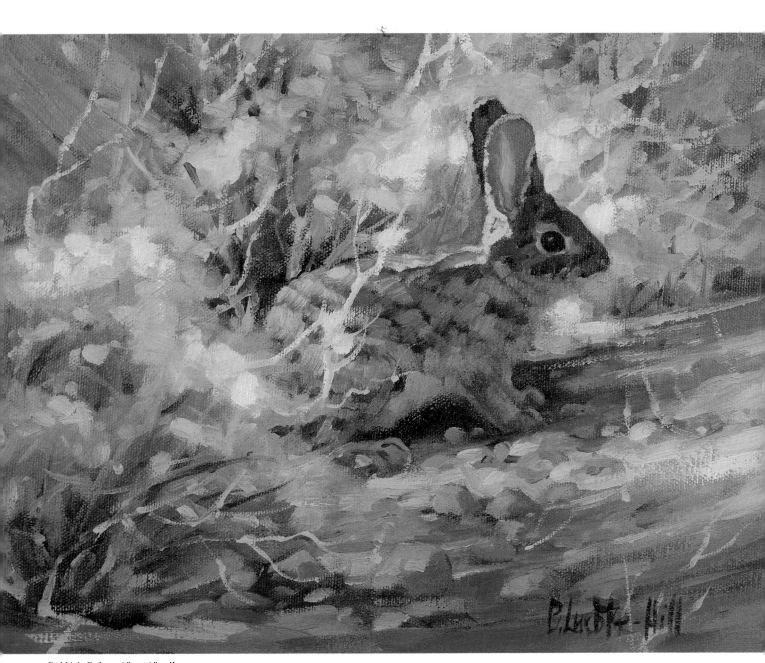

Rabbit's Refuge, 9″ × 12″, oil

This rabbit was right outside my house.

Park or Local Pond

Going to the park pond, or any pond, is a special treat for me, as I have a built-in love for ducks and geese. Many of my childhood years were spent on my grandparents' farm with all of the different animals I talk about in this book. One might say I had an early imprinting. In later years we raised several ducks as pets, so I find them most entertaining and amusing. Generally, if a pond has ducks, there are geese also. Here is an opportunity to notice the differences in their bodies, size and movements. Furthermore, you can get a lot of duck and goose drawing practice on an outing to a nearby marsh or bird refuge. A duck's a duck and a goose is a goose, whether wild or domestic, though there are notable anatomical and color differences among them, which I will talk about in detail in a later chapter.

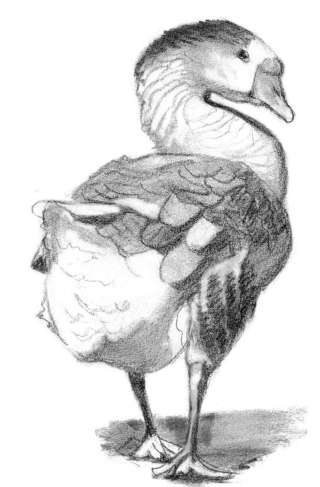

Geese are one of my favorite drawing and painting subjects.

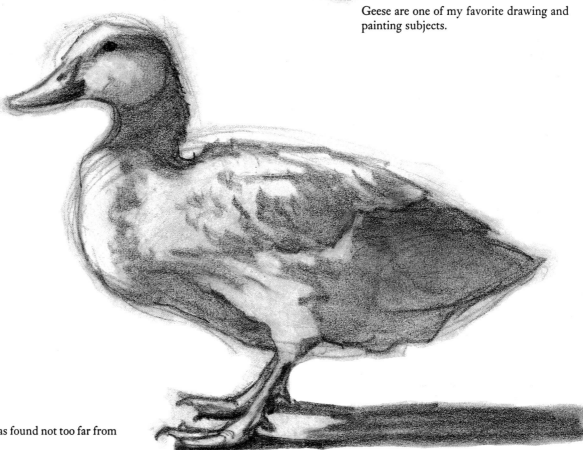

This puddle duck was found not too far from my home.

Painting Animals Step by Step

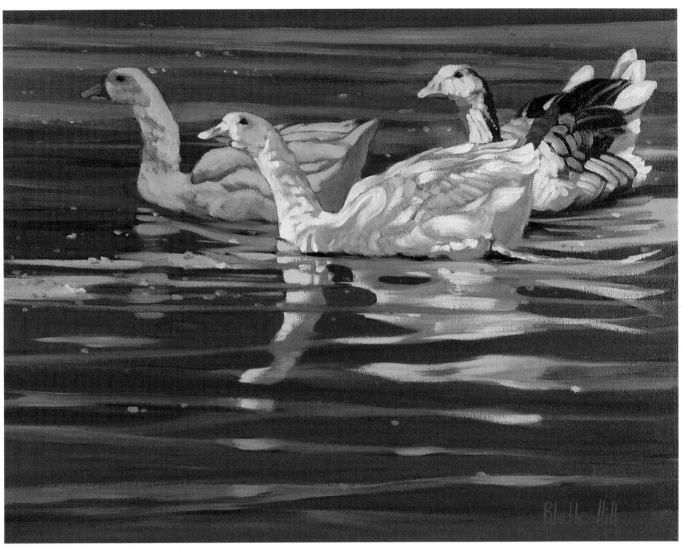

Secluded Waters, 18″ × 24″, oil

Waterfowl are very easy to find at local parks with ponds. I saw these three floating along at sunset. The low light highlighted their white feathers against the darkening water.

Field and Farmyard

Farmyards are peaceful, bucolic places. It's great to be in a farmyard where all one hears are the bird and animal sounds. No cars, no horns, no hustle and bustle of the city. The country is where one can find peace with the world. There may be barnyard odors, but they usually are not unpleasant. Give me fresh country air any day instead of a city street's exhaust fumes and hot asphalt. Barns are worlds of their own— quiet, shady and perfumed with sweet-smelling hay.

If you get acquainted with a local farmer, you will find him most co-operative in bringing animals within range of your sight and pencil. I've had farmers bring animals in from pastures to the corral to make it easier for me to see them. In our travels, I've had a burro handler release several burros into a small enclosure with me for sketching and painting. Some farmers allow you to venture into their fields with paper, pencil, stool and paints. Take all of the opportunities you can get to sit down and draw!

Sheep and goats are range animals a good part of the year. Unless you know a farmer who has a few in his pen or barn or someone who has a pet sheep or goat, you might have to visit the range country where they are pastured. I find it very pleasurable going out into the pasture to follow the flock. It's more of a walk with the flock, as they are grazers;

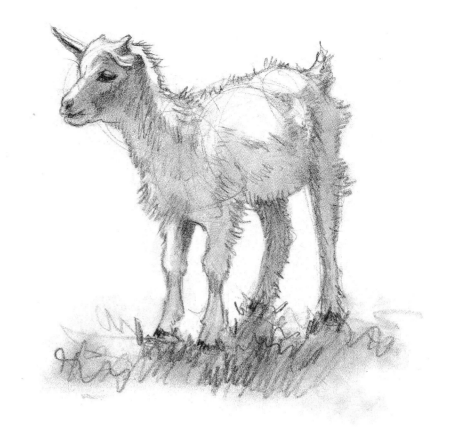

Sheep and goats will sometimes pose for you for short periods. Catch their overall shape quickly; leave the details for later.

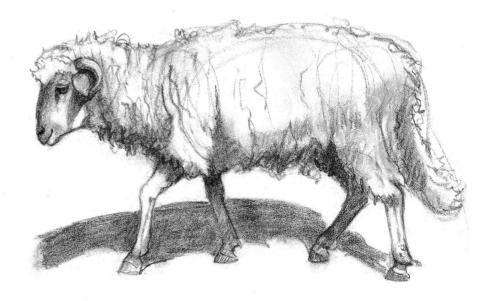

they never stand still. Learning to sketch on your feet is helpful in this situation. Sheep have placid personalities, while goats are more active and curious. Sheep are slow movers, constantly foraging; goats are faster and generally more inquisitive while they're grazing.

Dairy cows are common on farms near most large cities, so finding them isn't a big problem. Stockyards are also not too far away, but not too pleasant to visit. Ranch or range cattle are much more fun to pursue because their surroundings are ordinarily so pleasant. Once in a while you'll find you have to pick up your painting gear and travel a ways as the animals wander. Before going out into the pastures with range cattle, check first with the owners. They will know best the hazards in the field, like angry bulls, and so on. When I wanted to paint dairy cows, I called a university dairy farm and asked for permission to visit the herd. The handler was most helpful and assured me it was safe to join the cows; I was free to go where I wished. Of course, drawing them

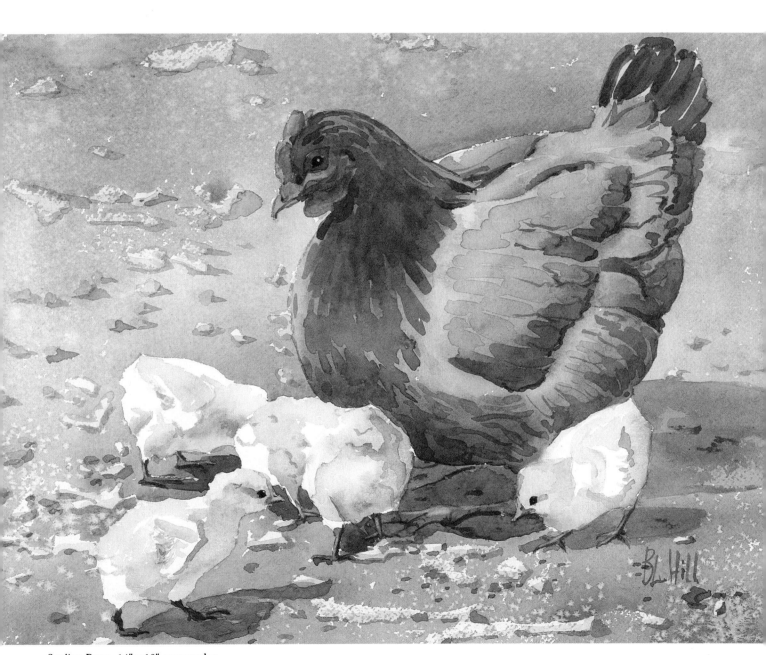

Settling Down, 14″ × 18″, watercolor

when they are corralled is a bit easier, as they aren't continually moving away from you; you only have to adjust to their changing positions. It's nice to find the occasional small farm with a milk cow or two, where the setting can harmonize with the subject.

Much the same can be said for horses; they are easy to locate and make good subjects for sketching and painting. Here in the Southwest, besides the regional farms and working ranches, we have riding stables, breeding stables, training stables, a horseracing track and dude ranches. It's not hard to find a friend who either owns a horse or knows where one can be found. Also, you might tune into the whereabouts and times of parades and rodeos in your area. Around here the opportunities are numerous. You can enlarge your ability to paint animals by finding a pet burro. Burros are fun to paint, and baby burros in particular, are real charmers.

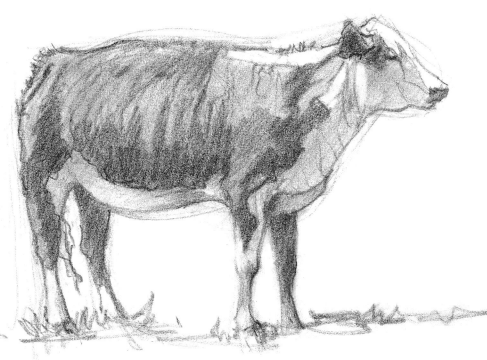

Cows are cooperative models. They will stand relatively still for a while.

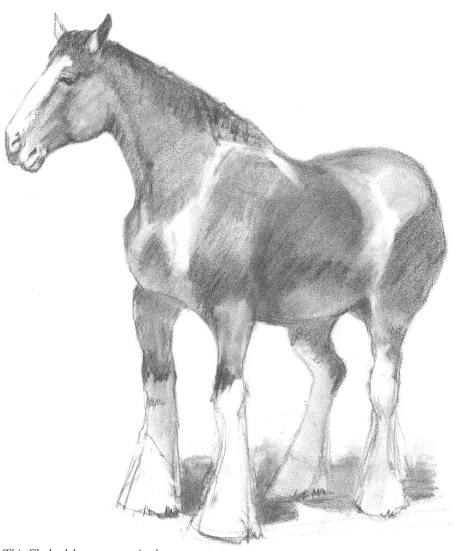

This Clydesdale was a massive beauty.

Painting Animals Step by Step

A Trip to the Zoo

Even though we think of zoos as having wild and exotic animals, they frequently contain a petting zoo for children. Most have ordinary domestic farm animals in this section—ones the children can walk among and pet with no fear or danger. Why not take your gear and sit among them too? You know they are used to people, they aren't going to wander away from you—you certainly have captive models. Besides, you might find it's fun to entertain and show the children a few drawing methods. You might inspire another budding artist!

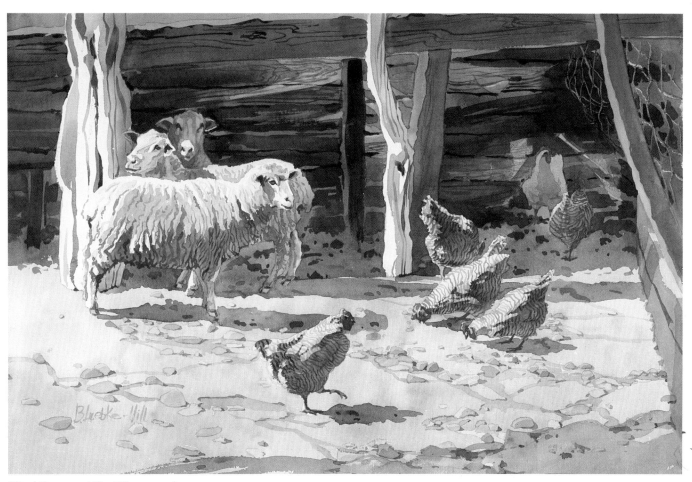

Mixed Company, 15" × 22", watercolor

Children's petting zoos often have a barnyard setting like this where you can spend some time drawing.

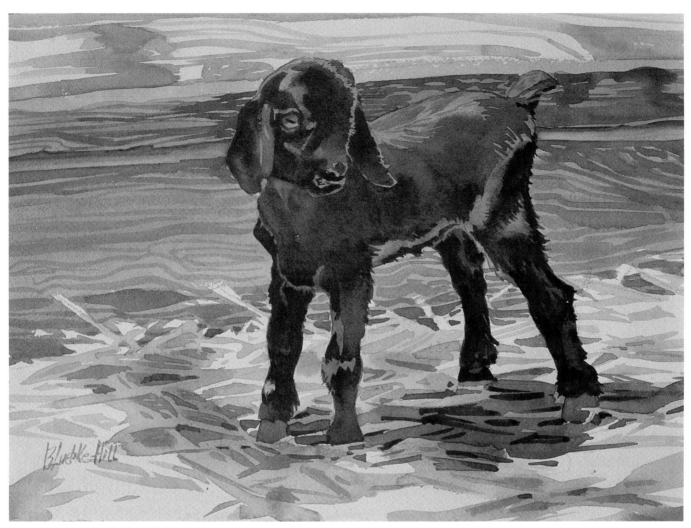

Baby Goat's First Day, 11″×15″, watercolor

Preparations

Find out how to improve your paintings by working—literally—in the field

Many people enjoy getting all of their art equipment together. That's part of the fun for them. Some acquire new pencils, sharpen them, buy new pads of paper plus the accessories—and then stop. Don't let that be your scenario. Keep going—have the determination to follow through. See how drawing feels. You will never know until you try.

So the wonderful day has arrived. You've decided to go out into the field to get those sketches, sample the atmosphere, feel the sun and fight the bugs. Check over your list of equipment before venturing out. It's annoying to be on location and find you've forgotten something.

Sketching in the Field

If you like to sit while sketching, a lightweight stool, perhaps one that folds, should be on your list. Don't take a chair with arms, like a lawn chair, as the arms are a hindrance to free movement of your hands and arms. Standing enables you to have the most freedom of movement. If you plan to stand, you'll need a sturdy standing easel, French or folding, with a supportive board on which to clip your drawing paper. We'll talk about easels later.

Pencils are available in varying degrees of softness or hardness—6B is a good example of a soft pencil and 6H would be a very hard pencil.

When I sketch on location I prefer to use softer graphite pencils (2B through 6B) and a smooth finished paper—it all works so much easier. However, if you're curious, you should investigate all the various pencils and papers available.

You will want to have a sandpaper pad and pocketknife along to keep your pencils sharpened as they wear down fast.

A kneaded eraser is best because it's so versatile. When it is warmed by your hand, it can be shaped for your purpose. You can use it flat as a blotter to lift out areas to be light-ened, you can rub out an area, you can shape it to a sharp point for lifting off small areas or thin lines, and you can also use it for general cleanup.

Those are the basic tools you'll need. Other accessories might be sunscreen, dark glasses, a sun hat, bug spray, perhaps even lunch and drinking water; all will add to your comfort.

If you have the room and the energy to carry more, a pair of field glasses can be indispensable for checking out detail on an animal that might not be comfortable close to you.

You might want to have on hand a range of pencil leads from hard to soft. It's not necessary to have them all, so experiment on different papers.

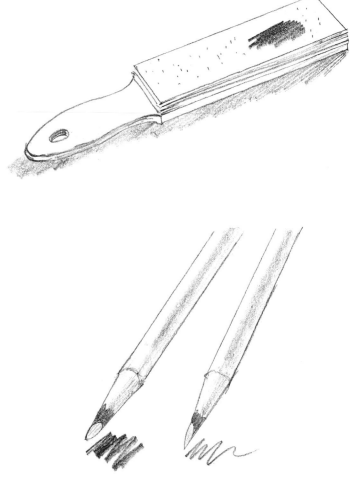

Use a sandpaper pad for sharpening pencils. Keep your pencils sharp and angled to one side. The flat side is used for flat shading strokes, then with a slight turn of the pencil you have a sharp edge for fine lines.

Field Painting in Oils

Easels

Perhaps after you have gone out and made pencil sketches, you may want to take it a step further and *paint* your subject out in the field. For painting in oils, the French easel is the easiest to use because it holds just about everything and is compact. It's my favorite. After setting it up, you have the option of standing or sitting. I prefer to stand, as I feel I have more freedom of movement in this position. It's helpful to be able to step back easily and appraise the progress of the painting. Also, there is now a smaller, narrower and less expensive model available that is lighter to carry. It even has straps so you can carry it on your back like a backpack. As a less expensive alternative, try a metal collapsible easel, now available in many different makes. It accomplishes the job just as well and is also much lighter to carry if you have to walk any distance with your equipment.

Canvases

There are many grades and styles of canvases. They range from stretched, ready-to-go canvases to canvas by the yard, all available in many different textures and content. For travel, I have flat canvas yardage pieces, already gessoed, cut to size (with an additional inch and a half on each side for later stretching), and taped to a piece of plywood. I generally don't paint large canvases when traveling and I limit the canvases to sizes that will fit flat in the bottom of my suitcase. After painting, when their surface is dry, these smaller canvases are easy to pack back into the suitcase, and they don't take up

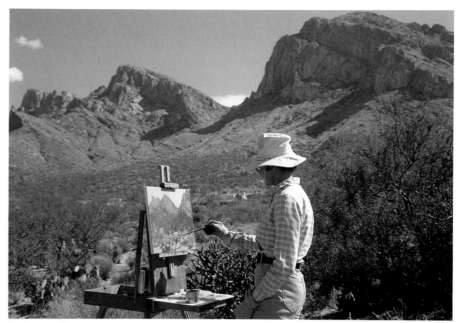

I take my French easel out in the field when I paint in oils. The drawer pulls out in front and holds the palette. The solvent sits either on the palette or in the drawer.

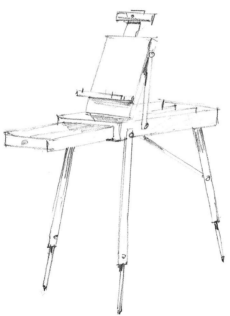

The French easel is versatile enough for standing or sitting and it carries almost everything.

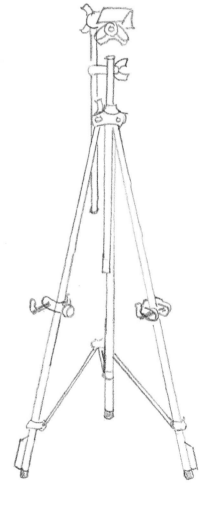

A metal collapsible easel is a little less sturdy, but lighter.

much room. As an extra precaution, I place sheets of waxed paper between the painted surfaces. After I get them home, I stretch them in the usual way onto stretcher boards.

If you're a beginner, you may want to use canvas pads and canvas boards, which are quite economical for practice and learning. The size of canvas you choose is a matter of personal preference. Small to medium sizes seem to be the most popular, as most artists paint to sell, and selling means the painting must fit into an average-sized room in someone's home. If an artist paints on huge canvases, he is limiting his market.

Brushes

Of course, the size of the brushes you use depends on the size of the canvases you are painting. If you are doing a miniature, using a 1- or 2-inch flat brush obviously wouldn't be appropriate. There are many different types and sizes of brushes for oil painting. Let's discuss the types I generally use; you can explore others if you wish. I use flats that are square-ended with medium-to-long bristles; brights that are square-ended with short bristles; and filberts that are thicker and have an oval end. My favorites are of hog bristle. Also, you might find some nylon ones that you like. The synthetic brushes and red sables for oil painting will produce a finer, smoother, more blended stroke than the hog bristle brushes. A lot de-

pends on the thickness of the oil paint, too. The bristle brush leaves more of a "foot print" in the stroked paint. For fine work and fine lines, I use an extra-long, square-ended sable or nylon highliner. My favorites (as shown below) are: ⅞-inch flat, ½-inch flat, ¼-inch flat, ⅛-inch flat, all in hog bristle; ½-inch bright, ¼-inch bright, both in hog bristle; ½-inch filbert, ⅜-inch filbert, ¼-inch filbert, all in hog bristle; plus the long-haired highliner in nylon. I like to have some "footprint" left in most of my painting strokes, so I do use the hog bristle brushes. I also prefer the stiffer feel of the bristle brush; it has a lot of snap and pushback when I make a stroke, a response I really like. In addition, I use the largest brush I can for a specific area I'm painting, as this gives me the best results. The large brushes do the bulk of the work, then they are supplemented by the smaller brushes to complete the detail. When you paint larger canvases, use larger brushes.

Palettes

Palettes in many different shapes are available in the art stores. If I'm using my French easel, I use the rectangular wooden palette that comes with it. If not, I have a typical curved palette that is comfortable to hold. It is made of wood that is covered with white Formica. Art stores carry clear Plexiglas palettes, white Plexiglas palettes, and wooden palettes with or without a durable white surface ap-

plied. I prefer the ones with a white surface, because it is easier to judge colors. You can also buy disposable palettes made of sheets of paper impermeable to oil paint—really handy when it comes to cleanup.

Paints

Colors are a personal thing. We all express ourselves in different ways and a lot of this expression is achieved through color usage. The colors I use most often are cadmium yellow light or sometimes Winsor yellow (both cool yellows); cadmium yellow medium (a warm yellow); raw sienna and burnt sienna (both earth colors); scarlet lake (a slightly warm red); permanent rose and alizarin crimson (both cool reds); cobalt blue (a middle, almost true blue); ultramarine blue (a warm blue); phthalo blue (a cool blue); phthalo green (cool); and white.

When a cool yellow is mixed with a cool blue, a lovely clear green is produced. When a warm yellow is mixed with a warm blue, a grayed green is produced. This green is grayed because a bit of red is included in both the warm yellow and the warm blue. The red is a complement to the green being mixed, so the color is slightly grayed. This phenomenon is consistent all around the color wheel. That is why I choose a warm and a cool version of all of the colors. Through experience, I have found I can mix almost any color I want with these colors.

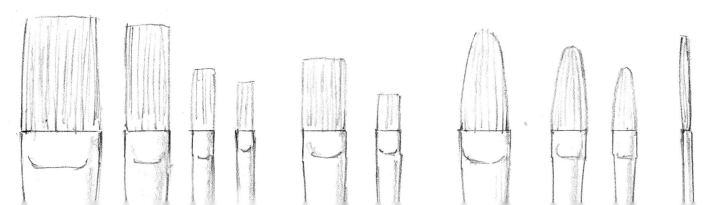

I prefer to use as few colors as possible in a painting to achieve unity in the work. I go by the rule that when a new tube color is introduced into a painting, it must be mixed with at least a few of the other colors to maintain unity. If it is not integrated with the others through mixes, it can stand out like a sore thumb and look like it doesn't belong. The simpler the palette, the greater the harmony will be.

Miscellaneous Equipment

Other equipment you'll need will be a palette knife, a paint scraper, turpentine, small containers for turpentine and medium, and paint rags. There are also oil painting mediums available for quicker drying, slower drying, etc. Try out different ones and see which you like best. I have used copal. It's great—it makes my paints nice and buttery. I have also used Liquin—it also makes the paint more buttery, and it hastens drying. You can continue painting on an oil in just a few hours. I have also made up my own medium, which I like very much. It keeps the paints buttery, and in addition, the paint surface dries faster. Advice on mediums and the recipe for medium I use can be found in Ralph Mayer's book, *The Painter's Craft*.

So—with easel in one hand and a bag of equipment in the other, you are all set for a day of painting!

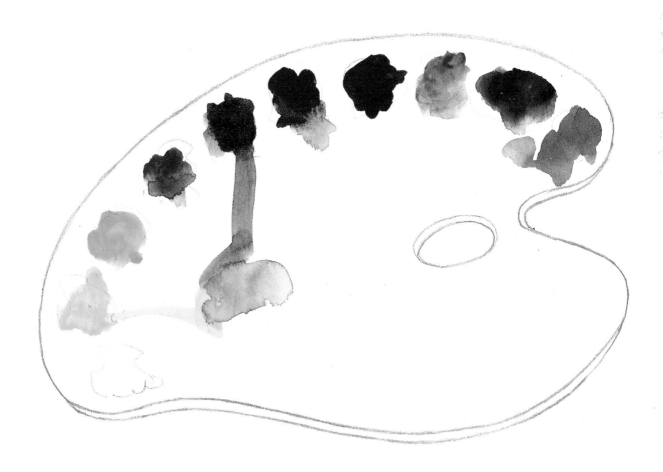

This is the palette I use at home in the studio, a comfortable curved shape that nestles in my hand and arm.

Field Painting in Watercolor

Easels

The equipment needed for field painting in watercolor is a lot different from that needed for oils. My husband has devised a special "easel" for me: The back of my watercolor board is fitted with a steel plate that has a ¼-inch nut attached to it; that nut fits onto the screw bolt on a camera tripod. The tripod allows my board to tilt in all positions the same as a watercolor easel. Then there is the standard watercolor easel where the watercolor board clamps onto a tilting bar. With either of these setups you can sit or stand to paint.

Paper

Watercolor paper comes in a variety of sizes, textures, weights, brands and prices. A normal full-sheet size is 22″ × 30″, which can be cut down for smaller sizes. There are also larger sizes available called ele-phant (25¾″ × 40″), double elephant (29½″ × 41″), and triple elephant (40″ × 60″), as well as paper in rolls. Paper also comes spiral-bound and in blocks of different sizes. The spiral-bound is found in sizes from 5″ × 6″ to 19″ × 25″. It's great for travel as it can be used as a water-color sketch book. The watercolor blocks come in a variety of sizes from 7″ × 10″ to 18″ × 24″. This product is handy because the paper is already stretched and ready for paint and water. The paper is supported by the block itself, so no other support for the paper is needed.

Watercolor textures range from smooth (hot pressed) to medium (cold pressed) to rough.

The weight refers to paper in reams of five hundred sheets. So, "90 pound" paper would mean that five hundred sheets of that paper would weigh ninety pounds. I prefer Arches papers in the 140 to 300 pound range. Any watercolor paper in this range of weights has enough body to keep buckling to a minimum. Lighter-weight papers will buckle more. I have enough to think about when painting; I don't want to be fighting a paper with hills and valleys. The Arches paper has a nice irregular surface with adequate sizing. If a paper has too little sizing, it soaks up paint and water like a blotter—the color will go dead. If the paper has too much sizing, the paint and water sit on top and slide around too much. There are many other brands of papers for you to try (many just as good as Arches) at a variety of prices.

Boards

The most useful watercolor boards are ¼-inch plywood or tempered Masonite cut to the desired size. Some people clip their paper to the watercolor board; some wet the paper, let it expand, then tape it down with butcher's tape or staple it and let it dry. When it's dry, the surface is taut and great to paint on.

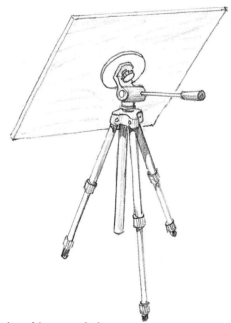

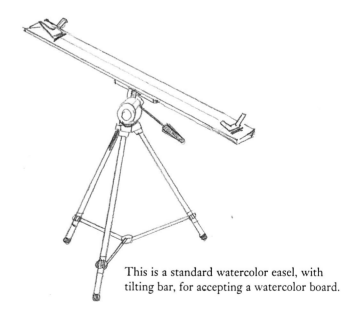

This is a standard watercolor easel, with tilting bar, for accepting a watercolor board.

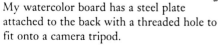

My watercolor board has a steel plate attached to the back with a threaded hole to fit onto a camera tripod.

Brushes

The brushes I like to use for watercolor are quite simple. Depending on your pocketbook you can spend a lot on sable brushes or a reasonable amount on synthetics. The synthetics have been perfected to a degree that they respond as well as real sable hair brushes and don't wear out as easily. My favorites are: a flat 2-inch wash brush, ox hair or synthetic; a 1-inch flat, sable or synthetic; a ½-inch flat, sable or synthetic; a no. 8 round, a no. 6 round, and a long-haired rigger or script, all in sable or synthetic.

Palettes

There are many watercolor palettes available. A visit to the art store will show you just a sampling. I use the John Pike or the Robert E. Wood palette for painting outdoors. I recommend these two palettes mainly because they are large and they have a large mixing area in the center. Small mixing areas tend to cramp an artist's style and force him to use smaller brushes when he should be trying to use as large a brush as possible. The paint wells in both are large and deep. That makes for ease in getting paint out, even with a big brush. They both come with a lid that helps to keep your paints moist. I have used a butcher's tray and simpler solutions that I worked out on my own. My indoor painting palette is described on page 23.

Paints

If you are just beginning and are watching your expenses, the student colors are less expensive and are just as good for learning and practice. I use Winsor & Newton colors; they are stable and reliable in their colors. However, there are many other good paint brands available. You may notice a difference in strength of color in some, but the differences aren't great. My favorite colors in watercolor are: Winsor yellow (cool yellow); new gamboge (warm yellow); raw sienna and burnt sienna (both earth colors); scarlet lake (a fairly warm red); permanent rose and alizarin crimson (both cool reds); cobalt blue (a middle, almost true blue); ultramarine blue (warm blue); phthalo blue and manganese blue (both cool blues); and phthalo green (cool green). These are much the same colors that I use in oil painting. I have chosen these colors mainly for their transparent properties, since I try and paint as transparently as possible. The only color of this group that is somewhat opaque is cobalt blue; I use it because it is almost a true blue. Only the three blues—cobalt, ultramarine and manganese—have very little staining. The rest will stain the paper to different degrees. Staining becomes a problem only if you plan to lift a lot of paint back off the paper. The three blues plus raw sienna and burnt sienna have some sedimentary properties. Paints with some sediment make nice washes and mixes with staining colors. The

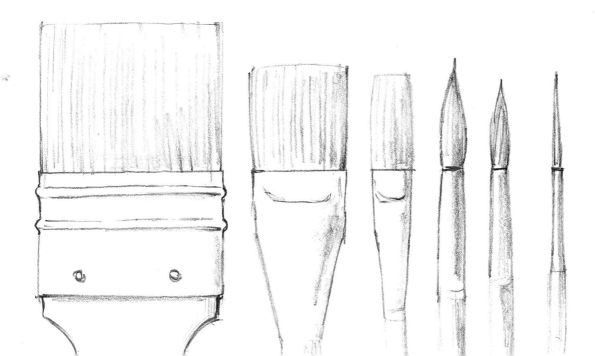

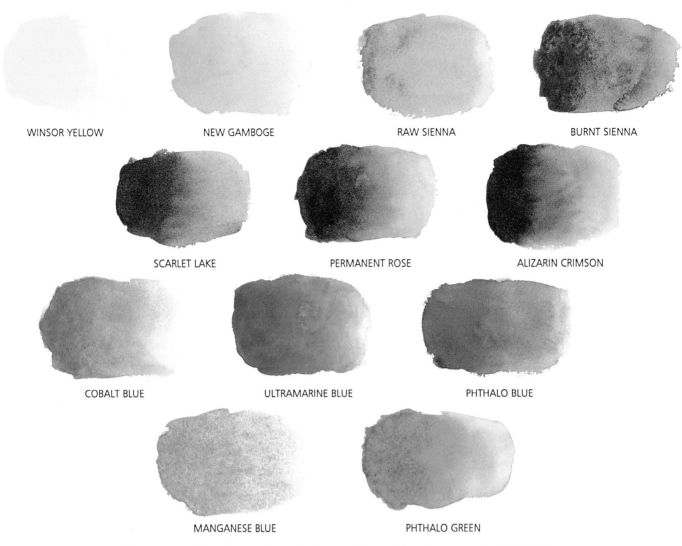

WINSOR YELLOW NEW GAMBOGE RAW SIENNA BURNT SIENNA

SCARLET LAKE PERMANENT ROSE ALIZARIN CRIMSON

COBALT BLUE ULTRAMARINE BLUE PHTHALO BLUE

MANGANESE BLUE PHTHALO GREEN

These are swatches of watercolor paints I generally use. The colors are painted with full intensity on the left and diluted to lighter toward the right. I use many of these same colors when painting in oils.

pieces of sediment settle into the low pockets in the paper, resulting in lovely color combinations, where one color stains and the other color in the mix settles.

I recommend staying away from blacks and grays; they are deadly. Learn to mix your darks from other colors—you will have greater control of your colors.

Miscellaneous

Other items one might need are tissues, a cosmetic sponge for lifting, a cellulose sponge for removing excess moisture from your brush and for cleaning your palette, and water containers (one for dirty water and one for clean). Those are the basic necessities. You may add items later to suit your painting style.

At Home in the Studio

In my studio I can switch from watercolor to oil or to any other medium quite easily. I have a drawing board or drafting table that moves from a horizontal position for watercolor to any angle of tilt, including upright, for oils. I also have a draftsman's swivel-type stool that can be raised and lowered easily.

For watercolor, I use a homemade plastic palette that I can fill with water. Small bisque-fired ceramic wells can be put in or lifted out individually for cleaning. The bisque-fired wells allow moisture to seep in, keeping the paints moist. I use a butcher's tray for mixing.

My side table, or taboret, is a cabinet large enough to hold lots of equipment. You can also use an old table, old desk, or whatever is available. When I was a beginning watercolorist, I just used the kitchen table.

Try Other Mediums

It takes time to become proficient in any one medium, but you shouldn't limit yourself just to watercolor, oil or acrylic. Try anything else that interests you and feels good. Your niche might be with some other medium such as pastels, colored pencils, charcoal, etchings, and so on. I have taken classes in pastel in the past, but now I would have to go back and practice before I would feel any adeptness in pastel. Someday I'll try it again, because pastel has a beauty and character all its own. The most important part is first mastering the drawing; then control of a new medium will come faster. Some people can switch back and forth between mediums with ease—maybe you can, too.

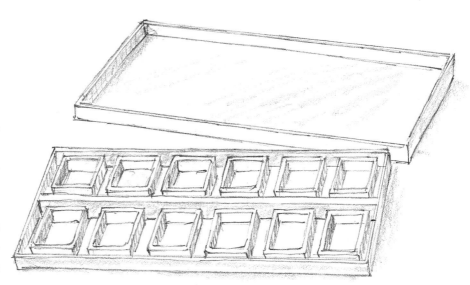

This is my homemade plastic palette with small bisque-fired ceramic wells. Water poured into the plastic tray is drawn up into the ceramic wells and keeps the paints from drying out. The lid keeps everything moist when not in use.

This is my studio setup for painting in oils. The drawing board tilts at any desirable angle. The horizontal support holds the canvas. My taboret holds brushes, solvents, paints, retouch varnish, and any other items needed. To switch to watercolor the horizontal support comes off and the board can be tilted to a more level position. The brushes are switched and the watercolor palette (seen in the lower left), water containers, plus paints are added.

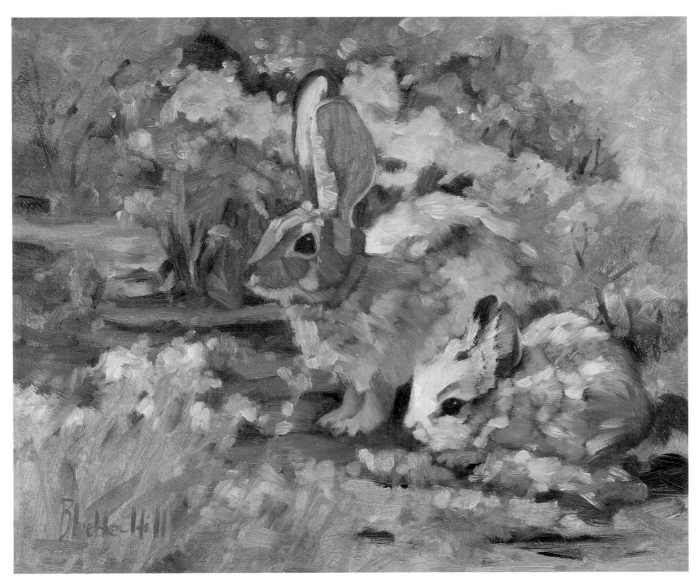

Feeling Secure, 11" × 14", oil

Let's Start Drawing

Learn how to get your animal paintings off to a great start — with a great drawing

In the words of Robert Henri, "Until you get started, you cannot finish." A good place to start is in your own house, with your own pet. If you don't own a pet, it's not a bad idea to get one. Research has demonstrated the therapeutic advantages of having a pet. Caring for a pet can lower your blood pressure and relieve stress. You may also find that drawing and painting your furred or feathered companion is good therapy.

Cats, pet birds and rabbits are relatively sedentary and may be a good choice if you are just starting out. It takes time and patience to develop a good relationship, as animals won't always behave as you want them to. Compared to the pets mentioned above, dogs are a little more active, but every animal spends some time in a less active mode. This is the time to run for pencil and sketch pad.

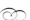

Sketching Your Pet

Cats do plenty of sleeping and napping or just sitting about in alert but pensive moods, providing ideal opportunities to sketch them—it's difficult to draw your kitty when she's bouncing off the walls! Pet birds like parrots and cockatoos spend lots of time on their perch where they are easily sketched. Dogs, because they are more active, are a little harder to draw, but even they take snoozes and rest in at-ease, alert poses.

Of course, a real help to the artist in getting good information is the camera. It can capture those poses that are too fleeting to sketch. There are pitfalls in relying on the camera, however, which I will talk about later.

Most of the time you won't find your pet in that perfect pose in a place that is convenient for you to work. Go ahead and try drawing anyway. You'll probably surprise yourself.

Watch for distinctive behaviors and mannerisms in different animals. Cats are usually independent and aloof. They seem inscrutable and mysterious. Dogs are more dependent; they want to please. There's truth to the stereotype about man's best friend. If you portray that feeling of total devotion and love in your painting, you'll have captured a lot of the character of dogs.

In observing ducks and geese, note how differently they walk. Geese carry themselves regally, with their heads and bills head imperiously high, while ducks waddle along, poking here and there, checking out their surroundings.

I've talked about the comical, clownish behavior of chickens. If you don't see it at first, keep watching. It's lots of fun.

The movements of sheep and cows seem plodding and almost mechanical. Their movements are slow and deliberate; they seem utterly absorbed in their grazing. Goats, on the other hand, are more spirited and mettlesome.

Horses have long been working animals as well as companions for fun and pleasure. The horse, a spirited and intelligent animal, has a nobility about its carriage. He's alert, wary and expressive. We respect horses, possibly because they are among our largest domestic animals.

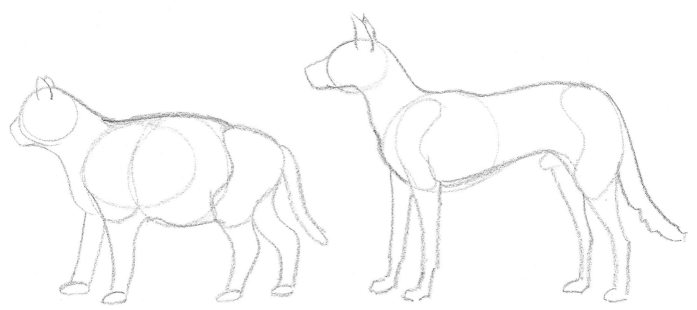

Cat. I start the gesture of the cat with an oval that represents the middle, or abdomen, of the body. Then I locate the chest area with a light oval. Onto the middle oval I add two bean shapes, one for the shoulder and front leg and one for the pelvis and rear leg. The legs are tubular with small ovals for the feet. The head is a circle with a rectangular muzzle added on. The ears are small triangles and the tail is tubular. I connect and refine the shapes with further drawing. The middle of the arched back is the high point.

Dog. I start the dog gesture-sketch with a circle for the chest area. I add an elongated abdomen and two bean shapes, representing the shoulder and front leg and the pelvis and rear leg areas. The head is a circle I attach to the body with a tubular neck. Then I draw the square muzzle. I make the legs tubular, longer and bonier than the cat's, and add the feet and tail.

Gesture Sketching

Sit, observe and draw. Do gesture sketches—many of them—to develop a familiarity with your subject. Then develop some of your sketches further, keeping in mind that the animal's form is most important. Note the way the fur or feathers lie on the body. Note typical movements of the head, neck, wings and legs. Try to accurately capture the animal's pose, because any awkwardness or unnaturalness will distract the viewer from your message. Some ambiguity is all right, even desirable, in a painting. But the subject and the action should be clear to the viewer. Use the form of the animal, the drawing of its action, the colors and values and the positioning of elements in the painting to express it.

There are three general methods of painting animals. One focuses close-up on an animal with only bits of twigs, leaves or ground showing. Portraits are included in this category. Another portrays an animal as the center of interest in an expanded setting, perhaps one with trees, sheds, or a background of mountains and trees. The third is more of a landscape painting with animals in it, where the animals are rendered quite small. This is one that should be composed so that the landscape can stand on its own even without animals. Before concentrating on specifics, you should decide on the method and general effect you want to produce.

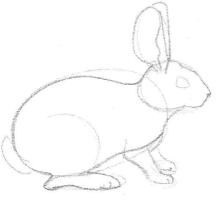

Rabbit. For the rabbit I start with a slightly bean-shaped oval for its body. I set the head into the body as an egg shape, with two more ovals—about as long as the head—set on the head as ears. I add tubular front legs with oval feet and oval back legs and feet, then refine all these basic shapes. First I flatten the ear on the front and extend it beyond the oval in the back. Then I angle the head at the eye ridge and indent and flatten the nose a little bit in the front. The neck line swoops down into the original oval and then back up for the backside. Finally, I draw the tail as a curved shape, add a suggestion of toes, and add an oval for the eye.

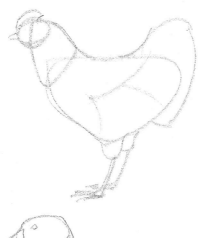

Chicken. The chicken gesture begins with a curvilinear triangular shape for the body. Another smaller one makes up the neck with an oval set into that for the head. A curved beak is added. The comb and tail may be added as curved forms, depending on the type of chicken. The feathered part of the legs are upside-down bell shapes. The chicken has three toes forward; the rooster also has a fourth on the rear of the leg and higher up. The wing makes an indentation halfway down in the body as it curves into the body. The leg and thigh create another convex area curving out from the body.

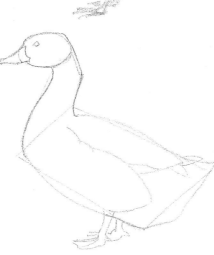

Duck. The gesture of the duck starts with a parallelogram shape for the body that is more rectangular and slimmer than that of the goose. The tubular neck has an elbow in it about halfway up, similar to the goose's, though slightly slimmer and shorter. The head is a slim oval with the eye placed forward. The duck's bill is also slimmer than the goose's and has a concave swoop. The feet have three webbed toes forward and a fourth toe higher and to the rear.

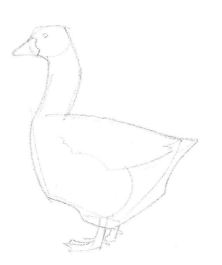

Goose. I start the goose with a trapezoid shape, then add a tubular neck with an angle in it at about halfway. This angle is important in shaping the neck. It is not a smooth curved line. I set the head on with an oval, draw a triangular shape for the bill, and place the eye in the forward part of the head. Next, with curvilinear lines, I continue to modify the basic shape of the body by drawing in the paunch (lower section of the belly that hangs down) and adding an angle or point about midway down the rear. I lightly indicate the wings and the convex lower leg shape. Last, I sketch in three webbed toes pointing forward and one toe a little higher up the leg in the rear.

Developing the Gesture Sketch

A gesture sketch is the preliminary drawing that captures an animal in the position it is taking. It is the process of breaking the animal's action down into its basic dynamic masses. The chest and abdomen are set down as ovals or sometimes circles. The rear pelvis (slanting out) and the rear leg and femur (slanting in), create one side of a set of parentheses. The shoulder (slanting out) and the front leg or humerus (slanting in) create the other side. I translate these formations into bean shapes that are added onto the body mass, while the legs, neck and tail are added as tubular shapes. The heads, of course, will vary depending on the animal.

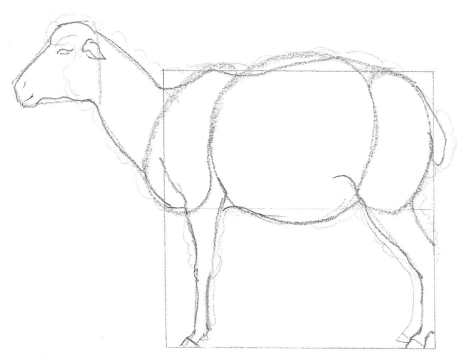

Sheep. I start the gesture of a sheep with a square as a guide. In the upper half of the square I draw a circle (the abdomen) that overlaps the top and bottom lines. The bean shapes I add locate the shoulder and front leg and the pelvis and back leg. I draw a tubular shape for the neck and a nearly triangular shape, flattened at the nose, for the head. The sheep touches the square at the shoulder, hip, rump, the bottom of the feet, and the lower chest line or sternum. The approach to drawing sheep and goats is the same. The sheep's back arches more in the middle; its neck and legs look shorter because its body is slightly bulkier. Its wool coat gives the sheep a softer, more rounded look than the muscular and angular goat.

Goat. This gesture of the goat starts with a square divided in half. A circle for the abdomen in the upper rectangle overlaps the top and bottom lines. I draw in the bean shapes that locate the shoulder and front legs and the pelvis and back legs, the tubular-shaped neck, and the triangular head with its flattened nose. Then I refine the lines. The body touches the edges of the square at the shoulder, hip, rump, the bottom of the feet, and the front legs. Note that the goat's legs are about as long as the body is deep. Its sternum rests on the halfway line. I indicate the ears, eyes, beard and horns.

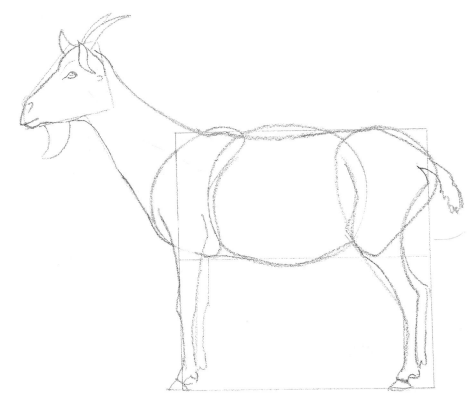

Painting Animals Step by Step

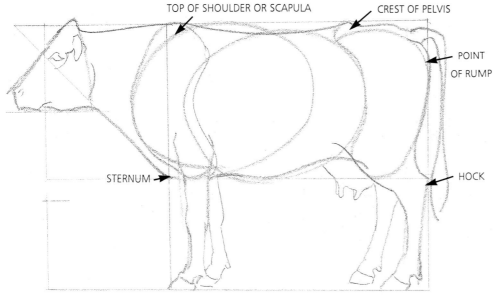

TOP OF SHOULDER OR SCAPULA

CREST OF PELVIS

POINT OF RUMP

STERNUM

HOCK

Cow. Cows are approximately square, so that's how I usually set them up. I draw a square, then extend the top line by about one half its length and drop a vertical from it. I divide that vertical line into thirds; the head will be about one-third the distance to the ground. The main part of the body takes up the larger upper section of a two-to-three proportion of the square. Into this upper section and slightly forward I draw the oval of the abdomen. I locate the rib cage with a second oval. The bean shape of the front legs and shoulder is bisected by the vertical side of the square. The bean shape that describes the back leg and pelvis fits into the square. The cow touches the edges of the central rectangle at the top of the shoulder, the top of the pelvis, the point of the rump, the hock, the belly and the sternum. I draw a line from the sternum at an angle to meet the top line at a point in front of the head, creating the neck line. The head is roughly trapezoidal. Then I do a refinement of these proportions so that the head sticks a bit above the top line, the muzzle extends beyond the forward vertical line, and the tail extends a bit beyond the rearline.

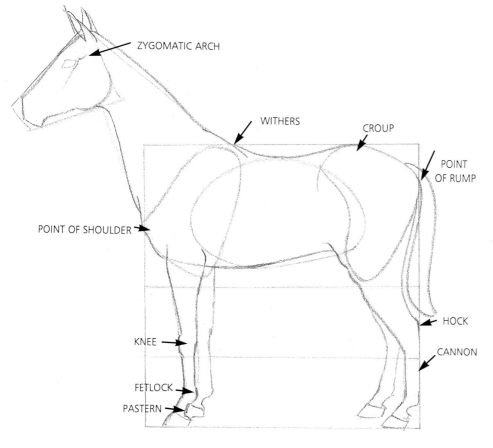

ZYGOMATIC ARCH

WITHERS

CROUP

POINT OF RUMP

POINT OF SHOULDER

HOCK

KNEE

CANNON

FETLOCK

PASTERN

Horse. The gesture of a horse can also be started with a square. I make a mark at one-fourth and at one-half the height of the square. The oval of the abdomen fits easily into the upper half, equidistant from top and bottom of this rectangle. I draw the shoulder and front leg as a curvilinear triangular shape and the pelvis and back leg as a bean shape. The sides of the square touch at the withers, the croup, the point of the rump, the rear cannon, the bottom of the hooves, and the lower point of the shoulder. I draw the triangular shape of the neck—the apex is the point of the ears when they are carried forward. Then I add the trapezoid-shaped head. From this point, I refine the drawing. Some points to remember: The zygomatic arch above and behind the eye creates a shadow; the knee joint on the front leg is lower than the rear hock; the fetlock is connected to the hoof by a smaller tubular shape, the pastern; and the tail extends beyond the square.

From Gesture Sketch to Final Drawing

This is a sketch of Jake, my daughter and son-in-law's dog. When I start to sketch, I look over the whole animal and determine the main masses of the body. I put those shapes down as simple circular forms. Don't consider putting in any detail at this point. Continue to refine; look for planes, corners and niches that help to describe the form. Then finish, taking into consideration the light and shadow.

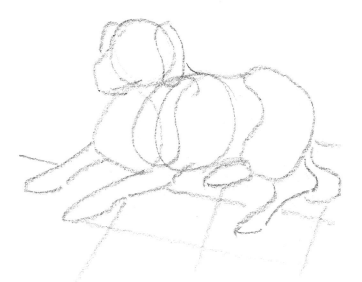

Block in the masses, in circular shapes, relating each mass to its connecting form.

Keep adding lines, simple at first, and block in all areas of the form.

Then slowly refine parts as you continue. Constantly check the relationship between forms to keep the proportions right.

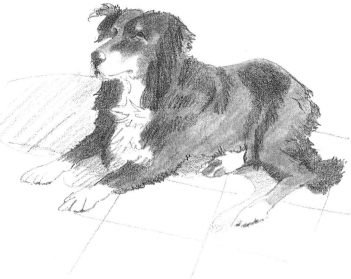

When all the forms and proportions are correct and relate well to one another, the local color and shadow values can be added.

Some Animal Comparisons

Many animals—not only mammals, but birds as well—have similar structures. Learning the basics is easy. You'll find that, from the artist's perspective, differences that distinguish animals are small. The chest and abdomen areas are the largest parts of every body. Legs have the same basic arrangement of bones, with only small differences in shape and proportion. Necks are all continuations of the backbone, though they vary in length, shape and thickness. Heads probably vary the most between animals, but they still have common structures.

It takes a bit of careful observation to determine the subtle features that will differentiate one animal from another. Study the differences so you won't run the risk of drawing ambiguously and confusing the viewer.

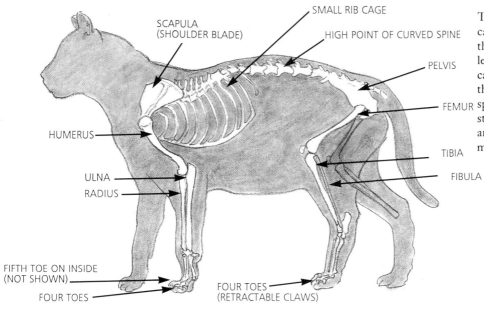

SCAPULA (SHOULDER BLADE)

SMALL RIB CAGE

HIGH POINT OF CURVED SPINE

PELVIS

FEMUR

HUMERUS

TIBIA

FIBULA

ULNA

RADIUS

FIFTH TOE ON INSIDE (NOT SHOWN)

FOUR TOES

FOUR TOES (RETRACTABLE CLAWS)

This incomplete skeletal sketch of a generic cat shows the relationship of the rib cage to the body mass. Note the length of the hind legs, especially the tibia. The femur in the cat is positioned at an angle. This angle, plus the added bone length, contribute to the cat's spring. The pelvis is angled downward at a steep angle from front to back. The backbone arches in the middle with the high point midway.

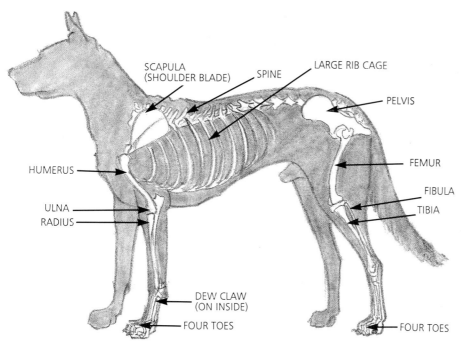

SCAPULA (SHOULDER BLADE)

SPINE

LARGE RIB CAGE

PELVIS

HUMERUS

FEMUR

FIBULA

ULNA

TIBIA

RADIUS

DEW CLAW (ON INSIDE)

FOUR TOES

FOUR TOES

This incomplete sketch of a generic dog skeleton shows the relation and position of the leg bones and the rib cage. Compare this sketch to the cat sketch. Note the dog's larger rib cage, the direction of the spine, the angle of the shoulders and pelvis. The femur is positioned more vertically than in the cat. The dog's chest cavity is also much larger relative to his body mass. His legs are longer, harder and more sinewy than the cat's.

The duck is characterized by its slim body. The duck's bill, like its body, is considerably slimmer than the goose's, and concave, though both bills have a "nail" on the end. The duck's neck is shorter and slimmer but has a similar "elbow" in the neck. The wing of the duck is partially covered by the side pocket. The secondaries partially show and the primaries stick out from under the tertials. There are two main types of ducks, puddle ducks and diver ducks, that vary in foot structure, breadth of wing, stance, habit and habitat. This is a drawing of a puddle duck. Close observation of the differences will result in a more accurate drawing. Puddle ducks surface feed, usually frequent small streams and ponds, spring from the water when alarmed, have no fleshy lobe on the hind toe, and have broader wings and a slower wingbeat. Their legs are positioned about halfway between breast and tail, resulting in a more level carriage of the body. The diver ducks dive to the bottom to feed, frequent larger bodies of open water, run across water to take off, have larger feet with a fleshy lobe on the hind toe, and have narrower wings and a faster wingbeat. Their legs are placed further back on their bodies, resulting in a more upright stance.

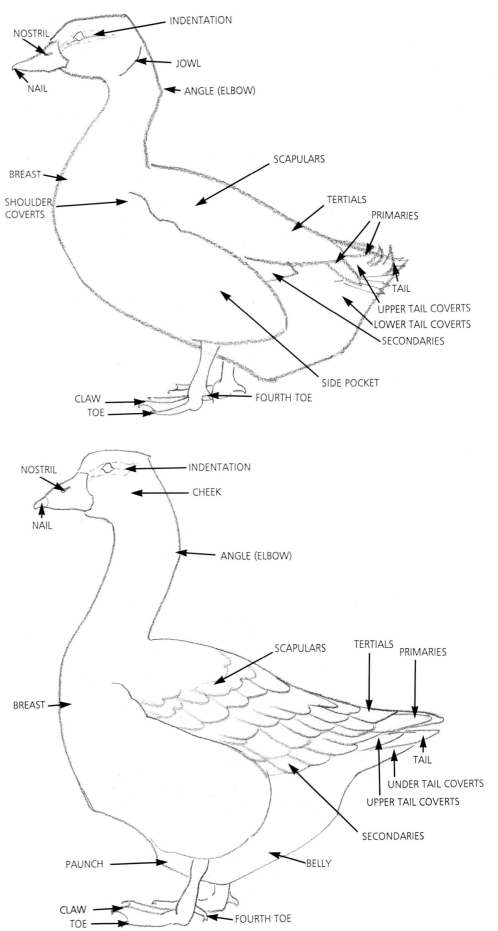

The goose is a larger, heavier, sometimes paunchy bird. Both ducks and geese have their legs attached on either side of their bodies, causing them to waddle when they walk.

Painting Animals Step by Step

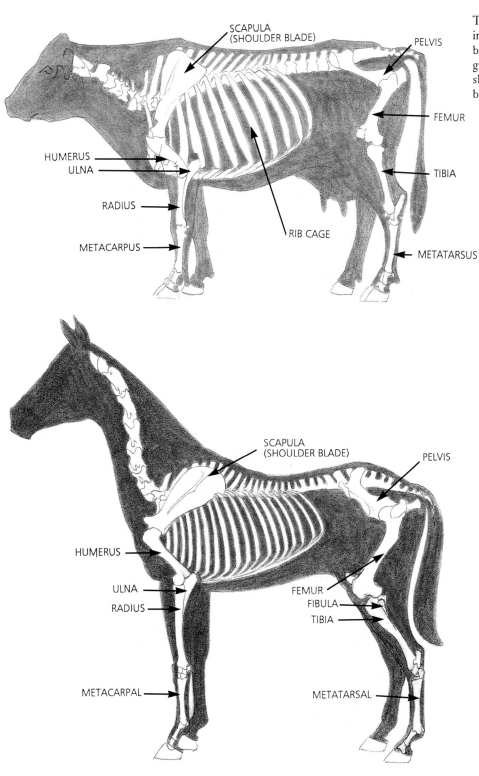

SCAPULA
(SHOULDER BLADE)

PELVIS

The cow has a stocky body, with legs shorter in relation to its height than the horse's. Its backbone is heavier and thicker to carry its greater relative weight. The neck is also shorter. Notice the cow's heavy shoulder blade and heavy bonework, in general.

FEMUR

HUMERUS
ULNA

TIBIA

RADIUS

METACARPUS

RIB CAGE

METATARSUS

SCAPULA
(SHOULDER BLADE)

PELVIS

HUMERUS

ULNA
RADIUS

FEMUR
FIBULA
TIBIA

METACARPAL

METATARSAL

The horse is slim and long-legged. The bones are light relative to the size of the body, especially those of the rib cage and spinal column. Notice the large femur (size and length) and tibia, plus the large and well developed gluteal muscles—all needed for hard running. The number of vertebrae are the same in the horse as in the cow, but the horse's are more elongated. The vertebrae in the tail of the horse are smaller than in the cow.

Facial Features

Make detailed drawings of eyes, ears and noses—points that need accurate detail to make your painting convincing. When an animal is featured as the subject of a painting, the viewer will focus on the head and face of that animal. So the facial features need to be carried out accurately and with more detail than the rest of the body. This is an opportunity to compare the eyes, ears and noses of the different animals.

Eyes

In most species of animals, the inside corner of the eye is lower than the outside corner. Note the shape of the eye and pupil. Are they large or small in relationship to the size of the head? Are they set into the head on a slant or are they more or less straight?

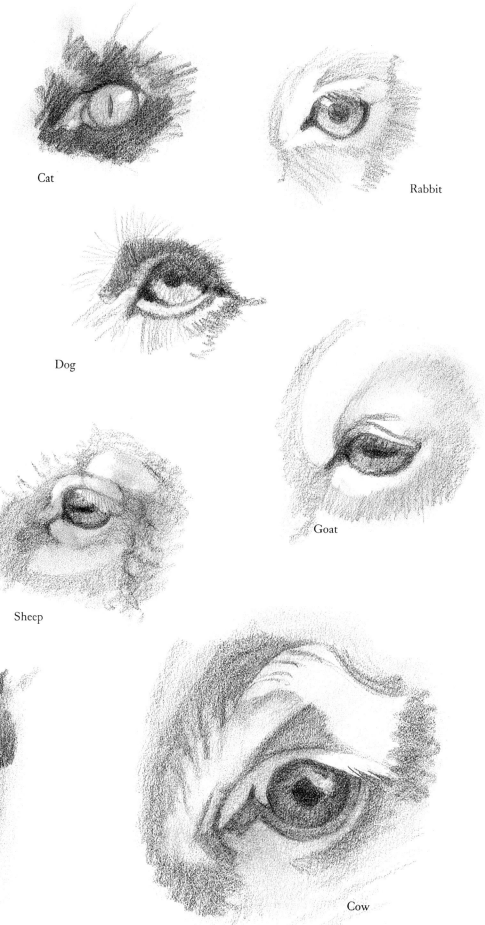

Cat

Rabbit

Dog

Goat

Sheep

Horse

Cow

Ears

The ears are cartilaginous cylinders. The rim of the ear closes at the base in some species and doesn't meet in others. Look carefully, noting the size of the ears relative to the head, eyes and nose. Are the ears rounded, pointed, narrow or broad? Note the placement of the ears on the head. Do they stick more or less straight up or out to the sides of the head?

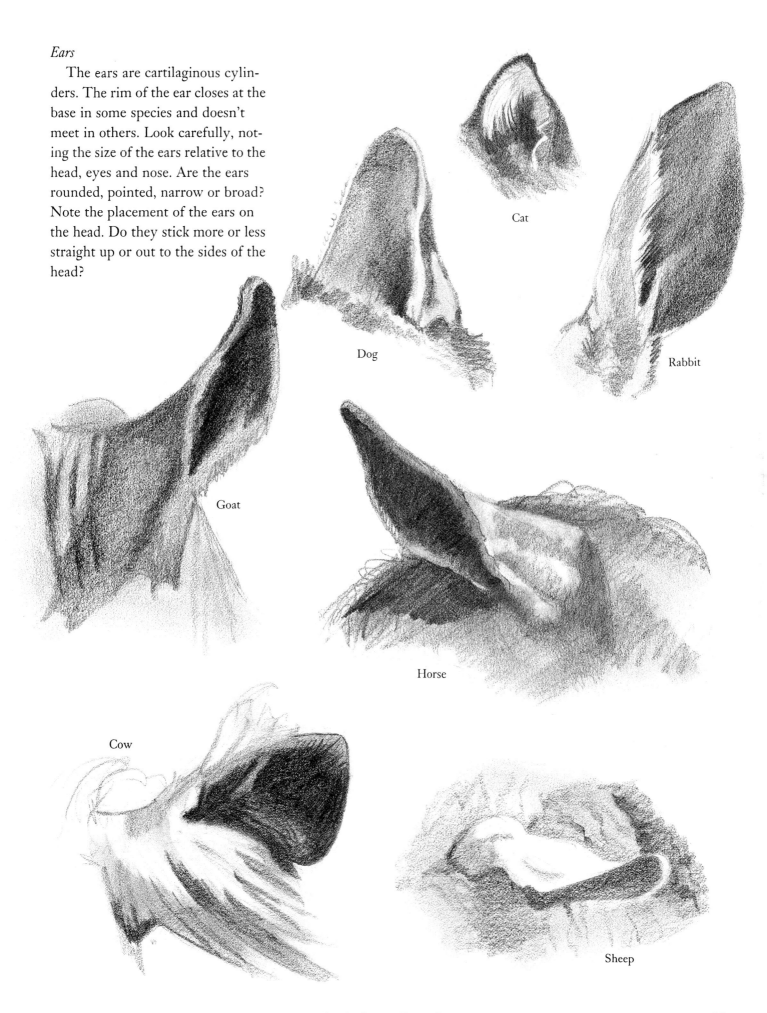

Cat

Dog

Rabbit

Goat

Horse

Cow

Sheep

Noses

Noses vary the most, as you can see in the sketches. Notice the anatomical differences between the species. The nasal cavity is formed by bone and then extended with the cartilage that forms the nostrils. Study the different sizes and shapes of noses. Are they triangular, rectangular or circular in shape? How does the nose compare in size to the head? Doing exercises in detail sketching will improve the authority in your paintings.

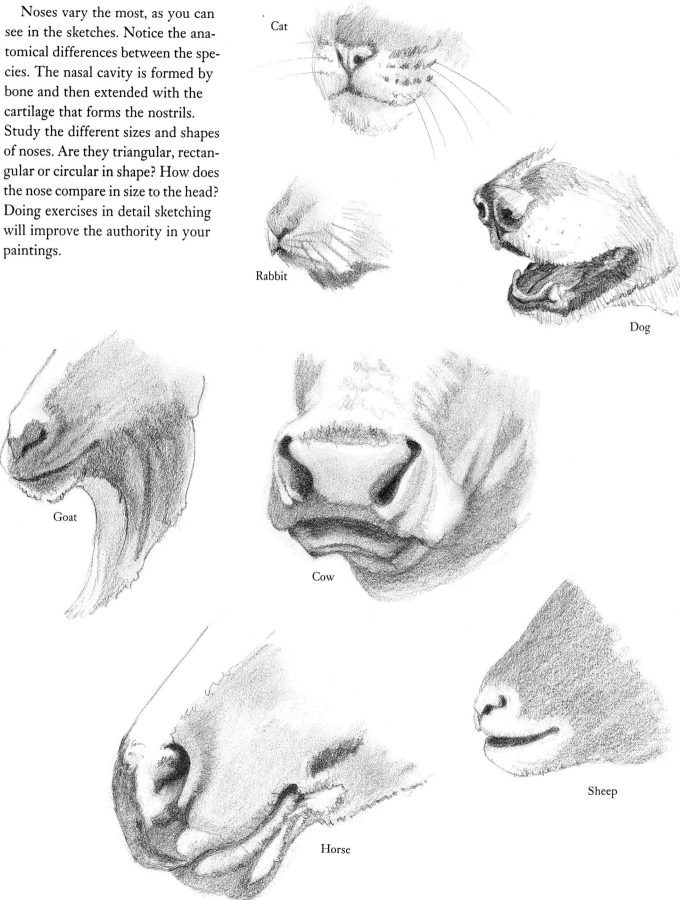

Cat

Rabbit

Dog

Goat

Cow

Horse

Sheep

Heads of Fowl

Compare the duck and goose heads. The duck's head is smaller and more delicate than the goose's. The duck's bill is slimmer and concave, while the goose's is sometimes more convex. The eyes in both are placed forward in the upper part of the indentation in the head. The detailed drawing of the chicken head shows how different it is from the waterfowls'.

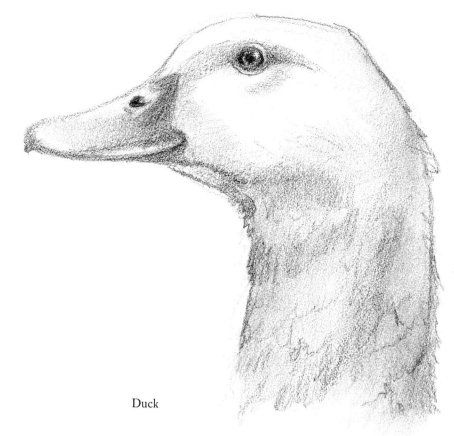

Duck

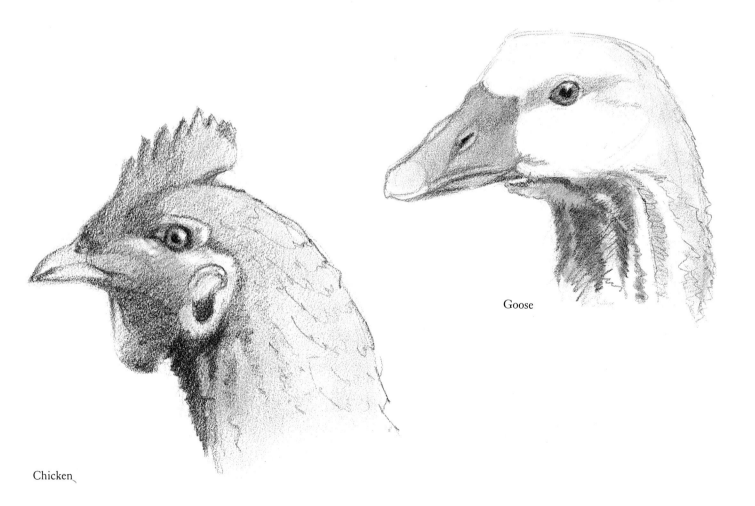

Goose

Chicken

Hair Tracts and Texture

An animal's hair lies in specific directions. When you are sketching an animal, indicate the hair direction by the way you make your strokes. When you are painting, observe the direction of hair-growth in your reference, then lay the paint down, making your strokes go the same way. This makes the end result more realistic.

When you observe an animal in the light, hair that is growing in different directions will catch that light in different ways. Hair catching the light will be more reflective and lighter in value, while hair next to it growing in a different direction will be darker. Hair whorls will reflect curved highlights. Short glossy coats will reflect the light more and appear lighter than furry coats. These glossy highlights will have sharper edges, while highlights on furry coats will have softer edges.

Likewise, some feathers on birds are soft, while others are more firm. The firmer feathers, like hard wing feathers, will reflect the light better than the soft body feathers.

You can also indicate hair texture by the way you put the paint down. A soft painted edge will look like soft fur, while a harder edge on the coat will appear less soft. The texture of a thick coat can be indicated with the brushstroke direction, without painting single hairs. Also, the depth of the coat can be indicated with dark strokes in the shape of the breaks in the fur.

This sketch of a dog's hair tracts demonstrates how a dog's hair grows downward from the neck area until it meets the chest, where the hair grows inward from the sides to the middle. The hair growing in different directions will catch the light differently, producing varied values of color. If I were painting directly from this sketch, I could easily tell how to make each brushstroke—in the same direction as the hair growth. Light values would be used where the light is reflected, and dark values where the hair changes direction and does not reflect the light.

A short glossy coat will reflect the light more than a soft furry coat. (Both of the dog sketches here are softer and furrier, so the coats reflect less light.) The highlights on the horse also have sharper edges. Where hair changes direction of growth it reflects the light more or less, depending on the way the light hits the animal and the form of that animal.

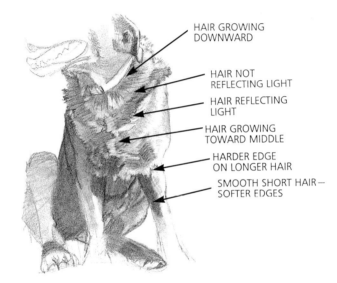

HAIR GROWING DOWNWARD

HAIR NOT REFLECTING LIGHT

HAIR REFLECTING LIGHT

HAIR GROWING TOWARD MIDDLE

HARDER EDGE ON LONGER HAIR

SMOOTH SHORT HAIR— SOFTER EDGES

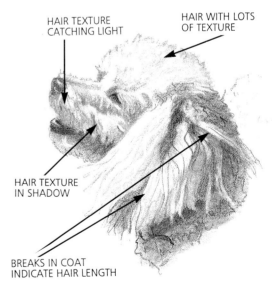

HAIR TEXTURE CATCHING LIGHT

HAIR WITH LOTS OF TEXTURE

HAIR TEXTURE IN SHADOW

BREAKS IN COAT INDICATE HAIR LENGTH

This sketch of a highly textured coat shows texture catching the light and texture in the shadow. It also shows how breaks in the fur can describe hair length.

HIGHLIGHTS CAN HAVE SHARPER EDGES

SHORT GLOSSY COATS WILL REFLECT MORE LIGHT

HAIR TRACTS, PLUS A CHANGE IN FORM, REFLECT THE LIGHT

TWO HAIR TRACTS— A CHANGE IN DIRECTION OF HAIR GROWTH

Animals in Motion

When you are sketching moving animals in the field, you will have opportunities to catch many poses. Draw quickly, getting the gesture pose down as fast as possible. That may be all you accomplish before the animal moves to another position. Make a new gesture sketch of the next position. Keep doing that, and after a while the animal will return to one of the first poses. Go back to that first gesture sketch and refine it. You'll find that all of the poses are repeated many times, so you'll have lots of chances to complete your sketches. Just continue working and refining as you go.

Pay specific attention to leg placement, making sure that the action is possible as portrayed. If it looks awkward when drawn—even if the action is possible—it is better to abandon the sketch than risk confusing or disturbing the viewer. Eadweard Muybridge has done a lot of work on the different gaits of horses and dogs. When portraying animals in action, it's a good idea to research his work to check for accuracy.

The field of scientifically accurate illustration has goals that are different from the ones we are pursuing. However, I highly recommend getting to know animal anatomy so that you can paint with authority. Three good books covering animal anatomy are: *Animal Painting and Anatomy* by W. Frank Calderon, *Art Anatomy of Animals* by Ernest Thompson Seton, and *An Atlas of Animal Anatomy for Artists* by W. Ellenberger, H. Baum and H. Dittrich.

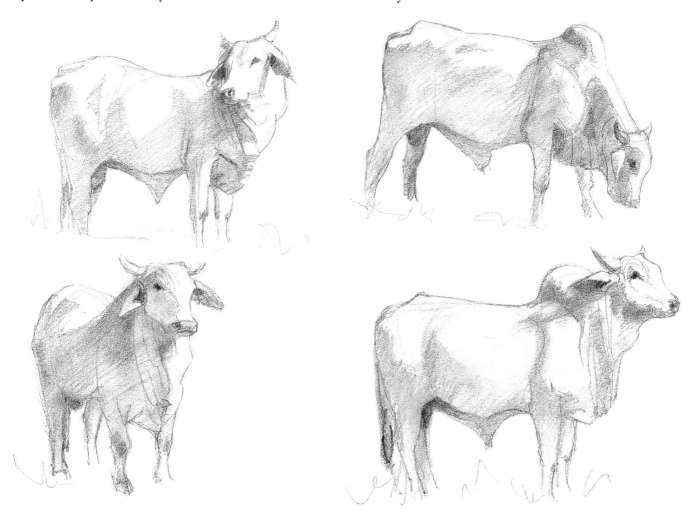

These are quick sketches done of a moving brahma bull. He was fairly slow moving so I had no trouble getting a simple sketch down. I would work on a pose until he would change position. Then I would sketch the new position. I would return to an earlier sketch whenever that pose was repeated, and so on.

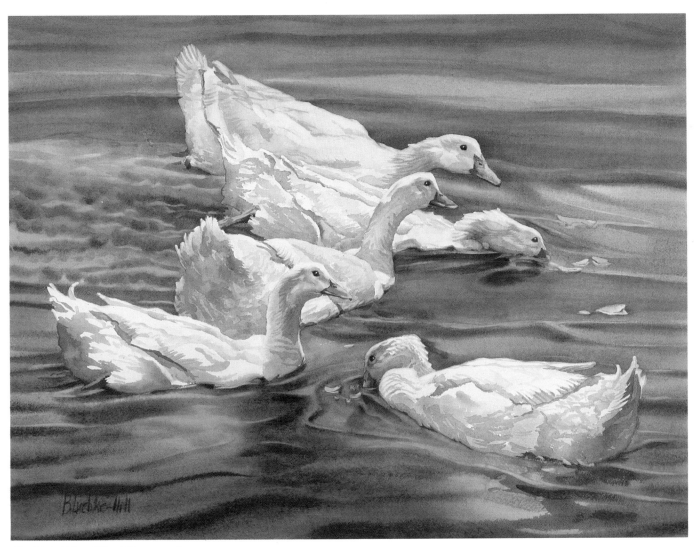

Playful Dabblers, 22″ × 30″, watercolor

Putting It All Together

See how to make your paintings stronger with these useful tips

Now let's talk about using the camera to assist you in gathering material. Photos are a good reference source, convenient to file away for future use, just like your sketches. It's helpful to develop a working knowledge of your camera and lenses so you'll know what results to expect when you photograph animals. This chapter will help you learn how to use your photos and sketches in developing your compositions. How will you position the animals in the picture plane? What parts of your photos will you use and what parts will you leave out? You should be aware of the camera's limitations and be able to recognize the distortions likely to crop up in your photos. I'll talk about how forms are depicted by light and shadow, and how the patterns on animals can help show the form. I will also discuss different methods of transferring your sketches to watercolor paper, methods that can be adapted to transferring drawings to canvases.

There's a lot to think about when you're putting everything together into a finished piece, but that's the challenge. In the end, your feeling of accomplishment will be worth the effort.

Using a Camera

The camera is a wonderful aid and research tool for the artist, especially one who paints animals. It's much easier to draw an animal that has been frozen in motion than one that is constantly on the move. Use the camera for reference and detail, but don't rely on it totally. Most important, don't project and then trace animal photos. Learn to draw from direct observation and from your reference material. When you leave out *your* interpretation and expression of that animal, you are subject to the camera's limitations.

Normal vision has about the same angle of view as that of a 50-55mm lens camera. A wide-angle lens, such as 28mm lens, is great if you want to get a photo of an entire pasture. But when you are taking a close-up shot of a cow facing you, you can get great distortion. Nearby objects look unusually large; distant objects appear especially small and far away.

A telephoto lens—from about 85mm on up—has a narrower angle of view than a 50-55mm lens, so it does just the opposite of what a wide-angle lens does. In a picture of a cow taken with a telephoto lens, background objects are brought up into the foreground and appear closer than they really are. The cow's rear end will look too large, compared to its head. Also, other cows behind the foreground cow will appear larger and seem to be stacked into a small space—not enough room for all those bodies! If you are aware of its disadvantages, though, it's nice to have a telephoto lens to use when you can't get close to your animal subject.

I use photos—mostly slides—in my work. I find it helps to have animals frozen in motion for detailed work, although I want to emphasize the importance of drawing from life—even from an animal that's in continual motion. When I work from slides, I use a reverse screen projection setup. I can sit in front of what I am viewing, and it is similar to looking at the subject in its normal setting.

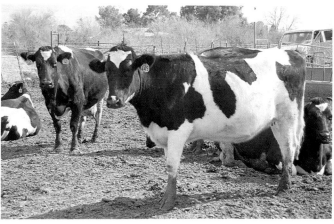

This slide of cows shows what a 50mm lens would record. It is very similar to what would be seen by the naked eye. Cows that are close appear larger; the farther they are from the camera, the smaller they look.

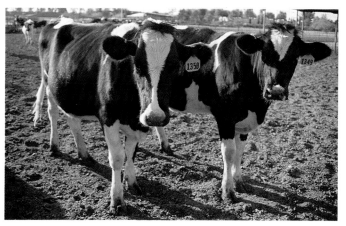

This is a 35mm wide-angle lens photo of a cow. Notice how the head is distorted and greatly enlarged; the rear end vanishes very quickly, appearing disproportionately small. This cow would have to be redrawn.

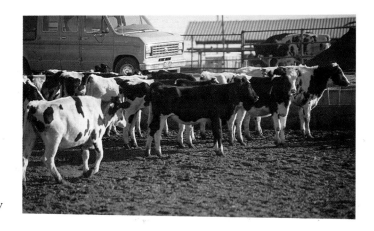

This is a 200mm telephoto of cows. Notice how the cow farthest on the right appears larger than the cows in the middle ground. The cows all appear to be stacked into a small area, when in reality there was plenty of room between them.

Painting Animals Step by Step

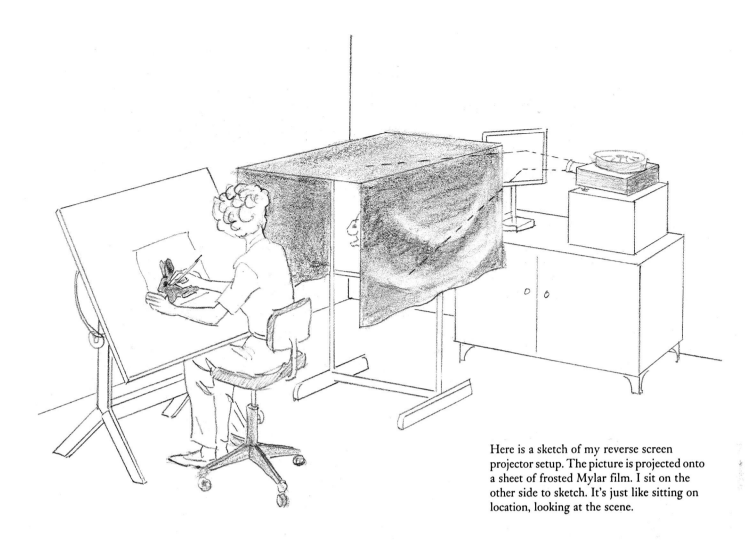

Here is a sketch of my reverse screen projector setup. The picture is projected onto a sheet of frosted Mylar film. I sit on the other side to sketch. It's just like sitting on location, looking at the scene.

This shot shows how I draw from the rear screen projector. I look at the image and then draw freehand. I never trace a projected photo.

Developing a Composition

Develop your animal drawings until you feel confident that you have recorded all the information needed. Make several thumbnail sketches, trying out different placements of the animals in the background you have chosen. If there are several animals, which one is the principal animal and which are the subordinate animals?

Pay attention to the location of the center of interest and how it fits into the background and foreground. After you have done all of your sketches and have bits and pieces to put together into a composition, divide your picture plane into thirds, both vertically and horizontally. The four places where the lines cross are points where it's best to place your center of interest. The upper left point is called the aesthetic center of interest. This spot draws attention, almost magnetically, so placing important elements in or near this spot has a pleasing effect. Avoid placing the center of interest right in the middle of the format; the result is usually boring and static. Also, don't divide your picture plane in half with either horizontal or vertical elements, as this too makes for uninteresting divisions of the picture format.

Two well-known compositional tools can help you develop your picture: the cartoon method and the viewfinder method. In the cartoon method, you draw the principal animals on separate pieces of tracing paper and then arrange the animals within the format until you achieve a satisfactory composition.

With the viewfinder method, you

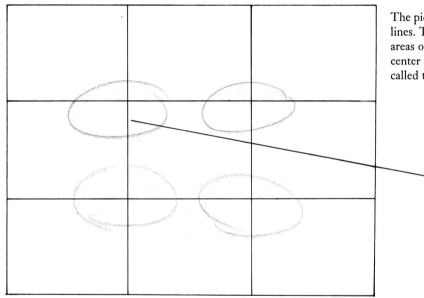

The picture plane is divided by four crossed lines. The intersections of these lines are areas of choice for the placement of the center of interest. The upper left area is called the aesthetic center of interest.

Don't place landscape elements in the picture plane in a way that divides it in half vertically or horizontally. The result is static and boring. Also, don't place the animal that is the center of interest in the center of the picture plane.

Painting Animals Step by Step

cut a viewer out of cardboard or heavy paper. (Mine is 2 × 2-inches. In fact, it's a cardboard slide mount from which the 35mm slide has been removed.) It's helpful to paint it black. After you have made your sketch, you can move the viewer around on the sketch until you like the composition it encloses. Sometimes moving it a little to the right or left, up or down, improves the whole picture.

This viewer is also helpful on location. I use it to find compositions in a landscape.

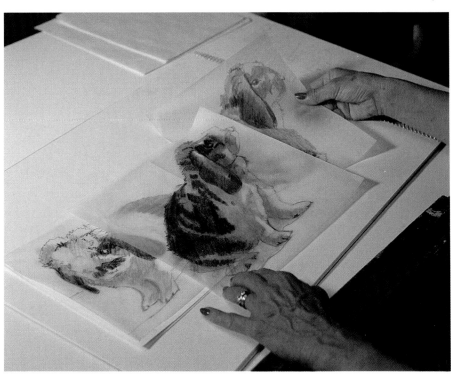

This shows the cartoon method of developing a composition. Here I have drawn the lop-eared bunnies on separate sheets of tracing paper. These can be shifted around until I'm happy with the composition.

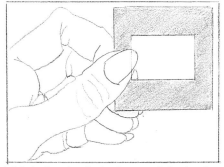

This is the viewfinder I use to help develop a composition. It can be used with sketches or out on location. It is a 2 × 2-inch empty cardboard slide mount, painted black for ease of viewing.

When I take the viewfinder on location, I can move it around to locate a good composition.

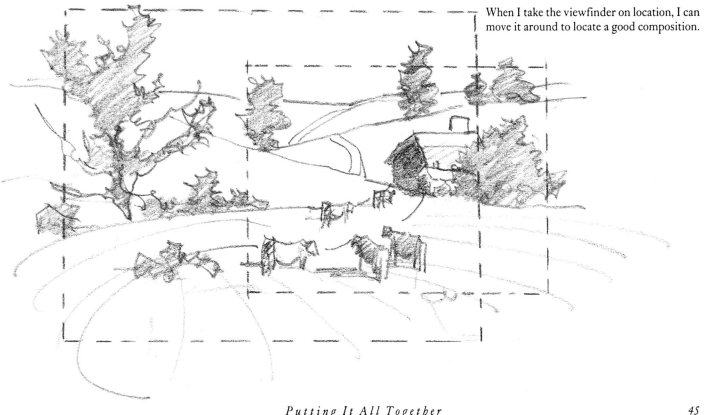

Transferring Your Sketch

I use two different methods to transfer my finished sketches to watercolor paper. The first method requires a sheet of graphite paper. I place the animal sketch right where I want it on the watercolor paper. Then I slip the graphite paper underneath. Using a hard lead pencil, I trace over the lines on the sketch, and the sketch is transferred to the watercolor paper.

You can easily make your own graphite paper by rubbing graphite onto a piece of tracing paper.

In the second transfer method, I turn my sketch over and trace all of the lines to be transferred on the back side with a soft (6B) pencil. Then I turn the sketch back so it faces up, position it on the watercolor paper, and rub the top side with a coin. This process transfers the drawing gently and does not damage the watercolor paper.

This shows the graphite paper method of transferring a drawing. I slip the graphite paper between the watercolor paper and the drawing, then trace the drawing with a hard lead pencil.

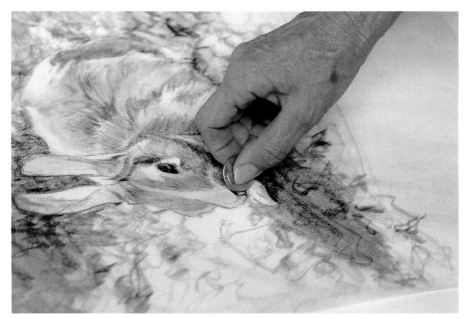

The coin-rub method of transfer. I trace the drawing on the back with a soft lead pencil, turn it back over, position it on the watercolor paper, and then rub it with a coin.

Composition Problems

Cropping occurs when part of your subject runs off or out of the picture area. Intentionally cropping part of a subject can add interest and vitality to a painting, but don't abuse the technique. There are places where subjects can be cropped without creating an uncomfortable feeling in the viewer. It might be all right to cut off a minor part of an animal, like the tail of a goose, but *never* its head. And don't cut animals in half—the forward part of the animal and at least three-fourths of its body should be in the painting. Beware of following your photo so closely that you include crops that do not enhance the painting. It's often better to rearrange your design to get the subjects properly into the painting. Placing an animal close to the picture's edge can create a tangent when the frame is added. You can also create a tangent by letting one animal just touch another. Lines that touch one another create a center of interest and if this area is not the desired center of interest, it is distracting to the viewer, and it takes away from the unity of the composition. Finally, don't put the frame line too close to an animal facing out of the picture format; this makes the viewer uncomfortable

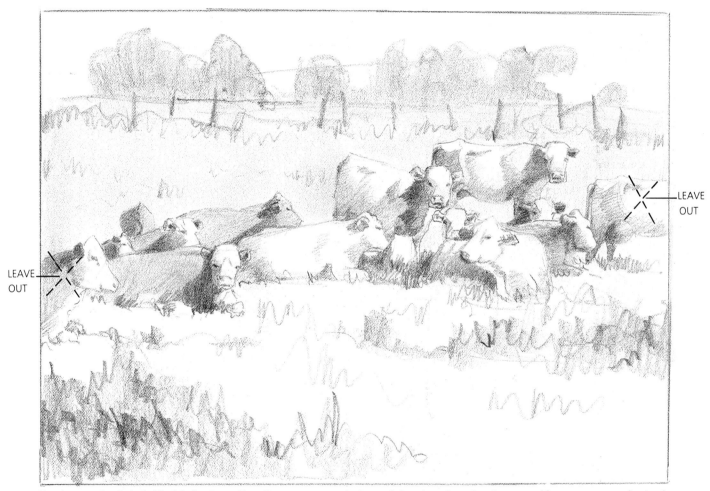

Don't cut animals in half with the frame line. Rearrange your design to bring them into the picture, and leave out parts of animals that do not add to the composition. Here, leaving out the right and left animal will not hurt the composition. Don't be a slave to your photos.

Don't create a tangent by letting a body part just touch the frame line. In this example, move the format up to better accommodate the rabbit.

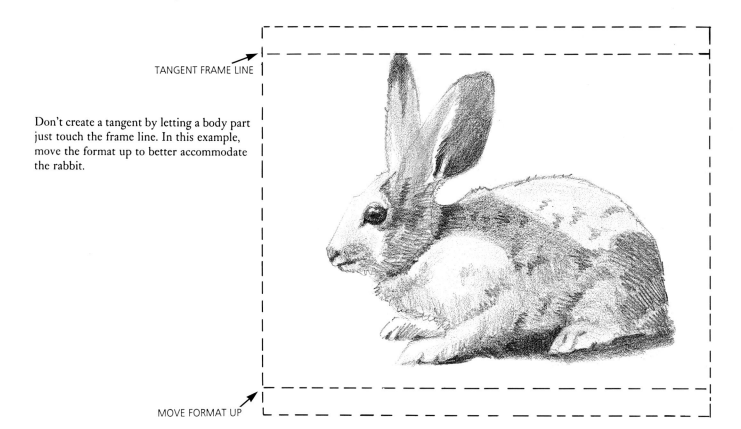

MOVE FORMAT UP

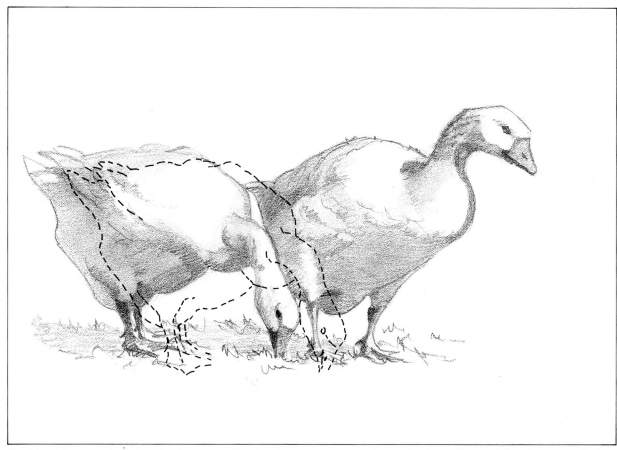

Don't position animals so that they just touch. Overlap them or move them forward or back. This will also give your paintings more depth.

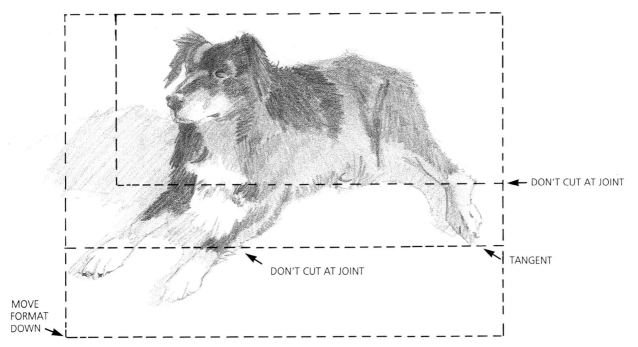

DON'T CUT AT JOINT

DON'T CUT AT JOINT

TANGENT

MOVE
FORMAT
DOWN

If you need to crop, don't let frame lines cut animals at their joints.

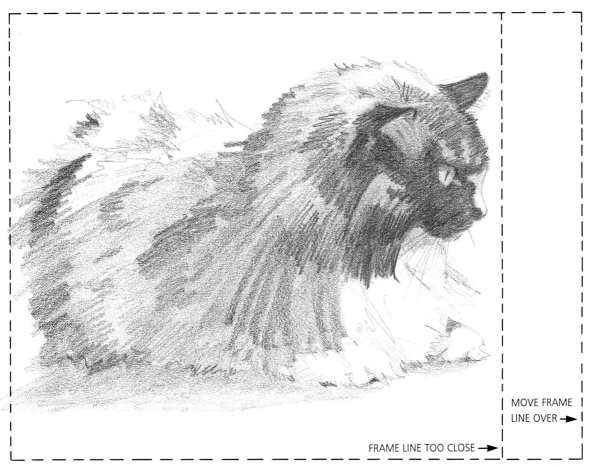

MOVE FRAME
LINE OVER

FRAME LINE TOO CLOSE

Don't squeeze an animal facing out of a painting by placing a frame line too close to the face. Move the frame line away, giving the animal more breathing room.

Photographic Pitfalls

Relying too much on photography can cause you to get into a rut where you copy the colors and shapes in the photo exactly. Using your sketches, memory and imagination instead of photos frees you to interpret the subject your own way. Think about your moods, your feelings, what caused you to want to paint that subject in the first place. Then take it from there. Paintings that look like photographs can be very dull!

You can tell an artist has relied too much on a photo when you see very dark or black shadows in his painting. In nature when you look at a subject, you can see into the shadows. Camera film, by and large, doesn't "see" into shadows; this results in black shadow areas in a photo.

Pay special attention to leg positions on walking or running animals. There are only certain ways a four-legged animal can walk or run. I've seen paintings and drawings where artists have shown animals' legs in positions that are impossible. As I have said before, there is extensive information available on animals in action in Eadweard Muybridge's book *Animals in Motion*. Just be sure that your subject's legs and feet are in positions that are natural and possible for the animal to assume.

I've already cautioned you against tracing your subjects from photos or projections of photos for the sake of your drawing skill. Another reason to avoid this practice is photo distortion. The problem lies in the way the camera's focal plane shutter operates. When you take a photo of an animal or person walking across your line of vision, the slot of the shutter, traveling in front of the film, produces an elongated image of the leg movement.

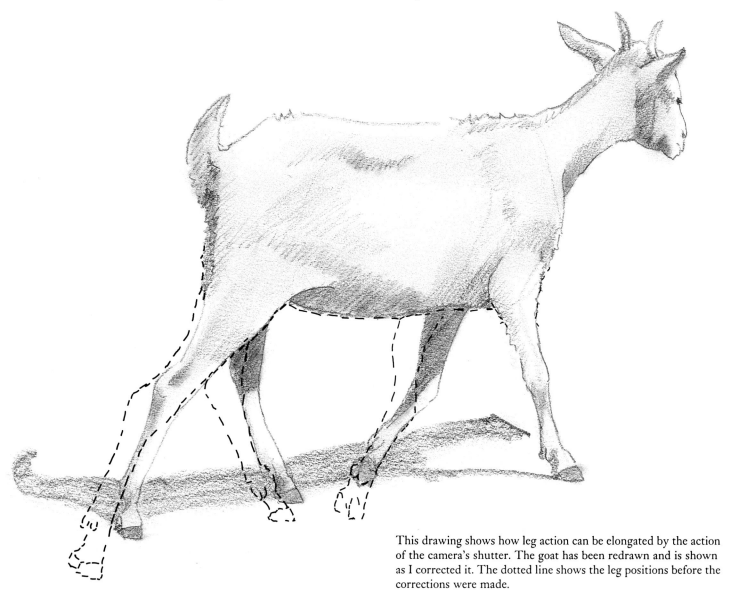

This drawing shows how leg action can be elongated by the action of the camera's shutter. The goat has been redrawn and is shown as I corrected it. The dotted line shows the leg positions before the corrections were made.

Rendering Light and Shadow

Animals have rounded, curving bodies. The way that light hits a body will depict its form. When you look at an animal in the sun, you see a light side (the lightest value), a shadow side (the darkest value), and an area of reflected light on the shadow side (a middle value). The reflected light is bounced back from the nearby surroundings onto the shadow side of an animal. If part of the body like an ear or a horn casts a shadow on another part of the body, the shadow usually has a sharp edge. If the animal's body curves away from the light side into the shadow side, that transition area has a soft edge. This is where the core of the shadow occurs, and it is usually the darkest value.

Preserving Form

If you concentrate more on an animal's markings or on the dappled light falling on it than on first establishing the basic light and shadow form, you risk making some serious mistakes, such as rendering markings with the wrong lighting or out of perspective, or allowing dappled light to make the form unreadable. The markings on an animal or the effects of extraneous shadows must be rendered in such a way that the basic underlying form of that animal is not destroyed.

For example, when drawing or painting an animal with irregular spots, you should draw the animal in its lighting first and then add the spots to that form. The spots will be rendered lighter in the light areas and darker in the dark areas.

An animal with regular spots or stripes must also be rendered in its basic form first, and then the spots or stripes added to that form. Stripes and spots must conform to the animal as seen in perspective. If the

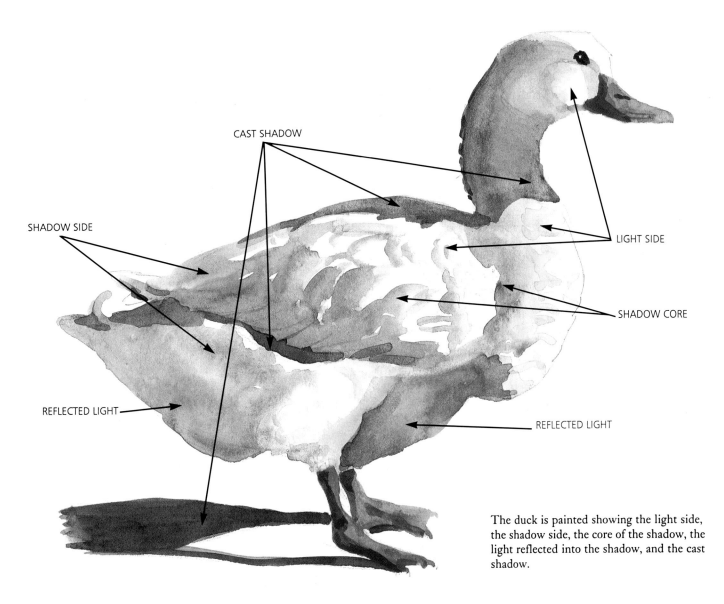

The duck is painted showing the light side, the shadow side, the core of the shadow, the light reflected into the shadow, and the cast shadow.

animal's form is foreshortened, its markings must be foreshortened as well. Stripes will run together, go from wide to narrow or even to a thin line, or curve when following the body form. Circular spots will stretch into ovals, even to very narrow lines, and curve to follow the body form.

Another problem arises when an animal is standing in the light and shadow of something that causes extraneous spots of light here and there, such as tree foliage. The animal's basic form must be rendered first and then the light and shadow pattern added to that. The basic form of the animal must show through any light and shadow pattern falling on it.

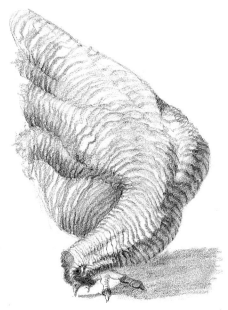

The stripes on the chicken are wide where they are seen in normal perspective and narrower, sometimes run together, where the perspective is foreshortened. The stripes follow the curvature of the body.

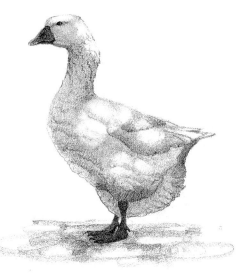

The goose's form must be rendered first, and then the dappled light pattern from the tree foliage added. The form must still show, lightly rendered in the light areas and darker in the shadow areas.

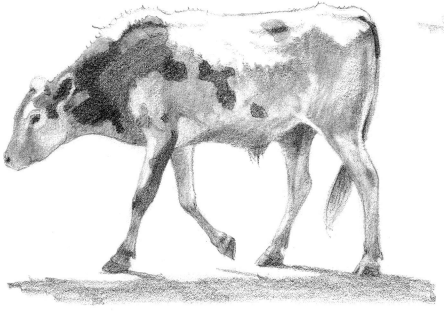

This cow was rendered in light and shadow modeling. Then the darker spots were added. Finally, to preserve the basic form, spots that were in the light were rendered lighter, and spots in the shadow were darkened.

Developing Your Ideas

You can use different photos in the composition of a single painting. Let's say you shoot a lot of photographs of cows, getting plenty of information. Then, you bring those photos back and choose different cows from different photos to make up a composition. Be sure the direction of lighting is the same for each cow you are using, or you will be creating problems for yourself. Also, make certain the animals you are using are in the same perspective plane. Perhaps you've photographed one animal from above and another from below. These two photos cannot be used together until the differences in perspective are corrected.

Fit your animals into the environment. Be sure your settings are authentic and realistic for the animal you are painting. Refer to nature for your information on settings and backgrounds. I keep a photo file of places I've been that look like good settings for animals. When I want to paint an animal and am completely blank on what setting to use, I go to my background file for inspiration.

When you are working from your sketches and photos, remember that what you leave out can be just as important as what you put in. Simplify your painting. The viewer doesn't want to see many niggling strokes depicting every twig or hair in detail. A painting becomes monotonous and boring when it's overdetailed. Work for broad effects and statements. The background should be subordinated to the animal if you are featuring the animal as the center of interest.

Here I put two shots together to make up a subject and background for a painting idea.

Coming Out of Cover, 9″ × 12″, oil

And here is how I combined my interpretation of the subject matter and background into a finished painting.

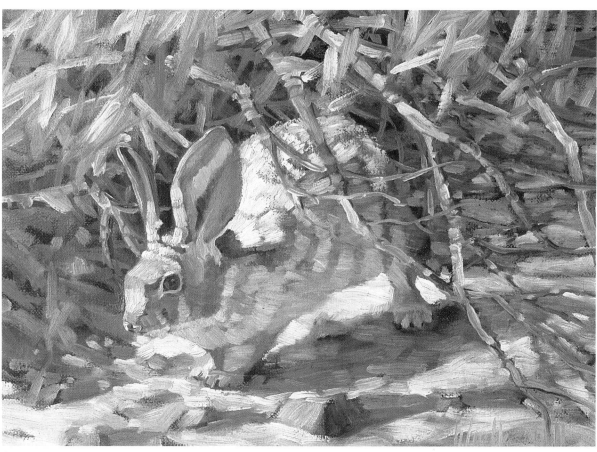

I used this shot as a reference and took some artistic license to make my own interpretation of the scene.

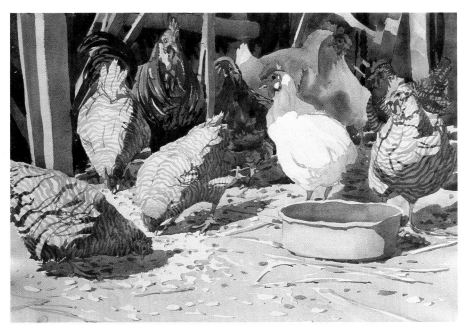

Henry's Harem, 15″ × 22″, watercolor

The striped chickens on the left were rearranged into better positions. A chicken was added on the right. The background area, with chickens, was lightened and the fencing left out. The ground area was simplified.

I used this photo for my reference material in making a painting of a hen and her chicks.

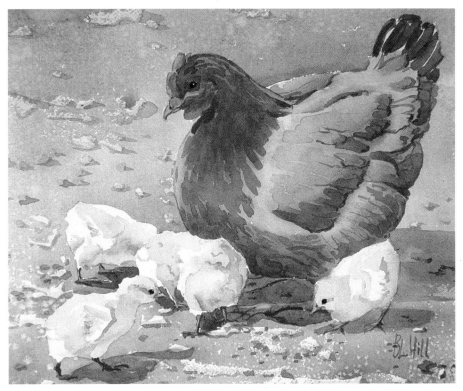

Settling Down, 11″ × 15″, watercolor

This is the completed painting showing how I simplified the background to make a more interesting painting. If the background had been painted as shown, it would have distracted the viewer from the main subject.

Go Ahead and Paint

When you confront a scene out-doors — or indoors, for that matter — you experience a particular feeling, an inspiration, an attraction to that scene. Open yourself to that feeling. What is it about the scene that turns you on, that makes you want to paint? Try and analyze what is special about it. Can you put that feeling into a painting? If you can identify the unique element or emotion there is in that scene that appeals to you, you can certainly put it down in paint. At first, it may seem difficult to convert your "feeling" into a painting, but it can be done. Remember: Nothing ventured, nothing gained. The flora and fauna about us can express moods that are sensed by the artist. This feeling is primal; it wells up inside of you. And not everyone has the same feeling for the same subject because we perceive stimuli in different ways. Emotions come first, from your heart, then your mind employs your knowledge of how to use pencil, paint and brushes to express yourself on canvas. As Henri says, "First there must be the man, then the technique."

An artist's ultimate goal is to produce an aesthetically pleasing painting. You *could* just settle for a photo of your pet, but wouldn't you rather have a beautiful painting — one that expresses your love and creativity — as a record of your animal friend?

This is a photo of haystacks in the Tuscany area of Italy. This place held special meaning for me. I can remember playing in the haystacks on the farm as a child, and this place took me back to scenes of happy memories.

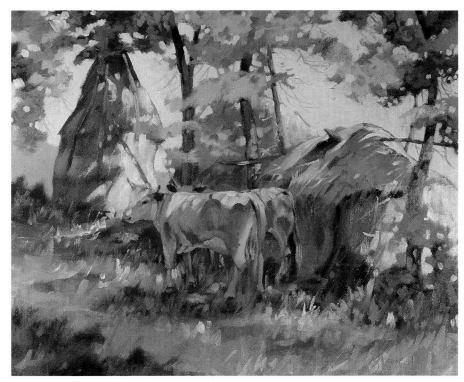

Tuscany Haystacks, 16″ × 20″, oil

This is my interpretation of the haystacks. I was impressed and moved by the subject, and that is expressed in the predominant use of warm colors in the painting. To me it has a summery, happy feeling. The cows were added for supplemental interest.

Patches

Painting Soft Fur in Oils

Our cat, Patches, is my constant companion. She follows me around just like a dog. She's a long-haired calico; consequently, her coat needs a lot of attention. She works on it herself continually, but if we don't help her out with a combing now and then, it tends to get ahead of her. Mats and tangles can develop quickly. All I have to do is take a comb and tap the stool and she jumps up for her beauty treatment. She enjoys being combed and I think she loves to look beautiful. At least we tell her how gorgeous she is; I know she knows it, too.

Patches likes to stick to a schedule; in that way she is very businesslike. She goes about her day in a methodical manner. I wanted to portray this orderly attitude she seems to have. I felt I could suggest this characteristic by the look on her face and her position on the stool. The markings on her face give her a rather stern look anyway. She has had her combing, and she sits there in a (typical for her) knock-kneed position. She is an extremely proud, elegant cat.

The special problem in painting Patches is to describe the texture of her fur. Her fur is so soft it's sometimes difficult to feel if you are actually touching her. Petting her is a balm to the daily stresses of life; it's calming, quieting and satisfying. The best part is she likes it, too!

To produce that soft texture of her fur, I felt I needed to paint thinly and to blend and soften the edges. So I used copal medium to soften my paints to a warm butter consistency.

Her colors are dark and subdued, mostly black and white with a very little tan here and there. I kept the background cool and made her darks a warm black, which brings her forward from the background. I used Winsor yellow, alizarin crimson, burnt sienna and ultramarine blue. The last three colors, when mixed, make wonderful clear darks that can be altered to warm or cool. Winsor yellow (a cool yellow with a hint of blue in it) when mixed with alizarin crimson (a cool red with blue in it) gives me a grayed orange, a good choice for my subject.

The important thing is how the fur and its edges are painted to say "a really soft cat." The edges can be painted with more definition in the face, as that is the center of interest in the portrait.

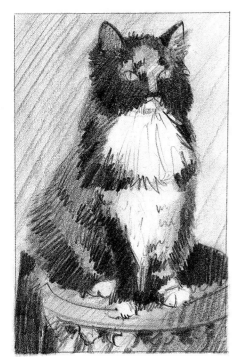

Here is a thumbnail sketch of Patches. She is quite dark in value, except for the white on her chest and tummy, so if I keep the background a lighter value, she will come forward.

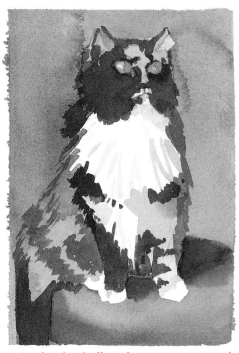

A color sketch allowed me to try out a cool background, giving the painting an atmospheric perspective.

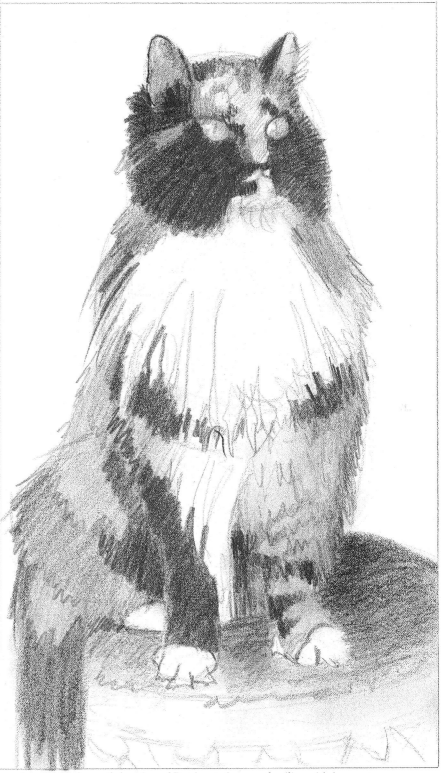

I made a detailed pencil drawing of Patches to become familiar with her anatomy.

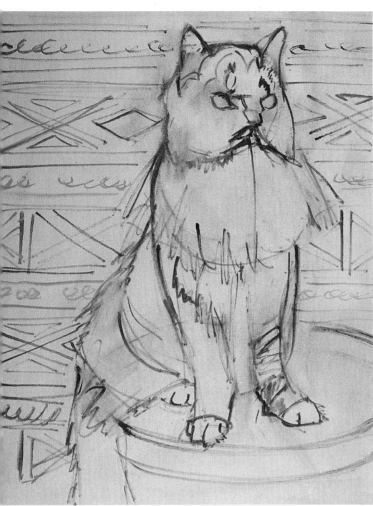

Using burnt sienna, I drew Patches on the stool using a no. 2 (1/4-inch) filbert bristle brush. Rules are made to be broken. Here, I placed Patches facing to my right with her body more on the right-hand side of the painting. She sat on the left side of the stool, her body and tail taking up the left-hand side of the painting. The center of interest—her face—is at the upper right. I think the painting is balanced and she doesn't seem crowded on the right.

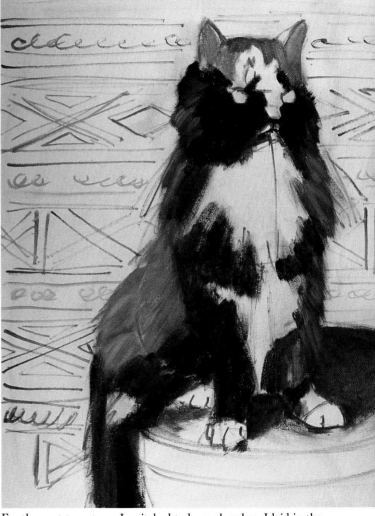

For the next two stages I switched to larger brushes. I laid in the first flat patterns with no. 4 and no. 6 filbert bristle brushes. Using copal medium to thin my paints to a buttery consistency, I painted in the darks. I wanted the oils to be thin and easy to work in order to blend the edges for a soft fur effect.

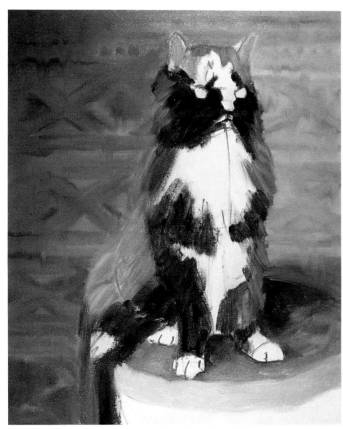

I painted in the background cool so that it would stay back. I kept the background pattern subdued so that it wouldn't detract from Patches. Keeping the edges of the pattern soft also helped it to stay back. I kept her fur soft on the edges to make it go back around her body. I blended one color into the other while the colors were still wet and movable. This gave me that softness I needed to indicate her fur texture.

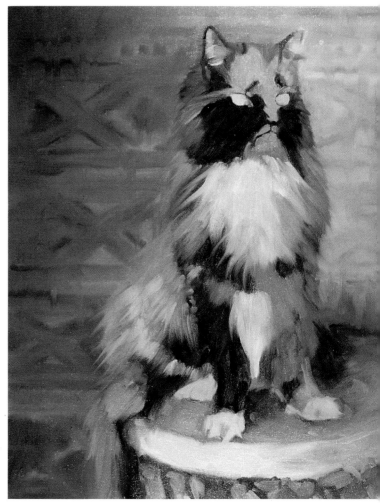

I painted more of Patches's fur, added the stool, and put in the color of her eyes. When we look at any animal or person, we focus mainly on one of the two eyes while the other remains slightly out of focus. That is one reason why the eyes shouldn't be painted identically. Another is that light generally hits one eye more than the other, making it appear different. Paint the eyes darker right under the lid as the lid casts a shadow on the iris.

A close-up of Patches's face shows that the eyes are not painted identically. There's a shadow at the top of the eye where the eyeball goes back into the face. Also the highlights placed in the eyes are of different sizes and are not painted with pure white paint.

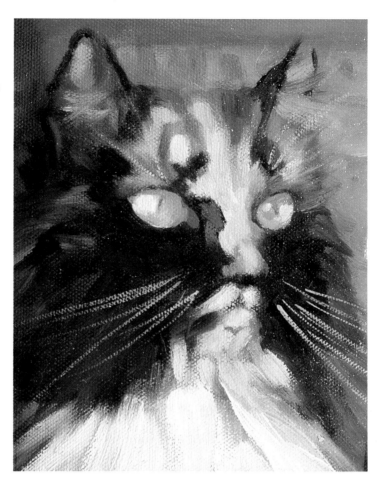

A close-up of the fur area shows a blending of edges into the background, making the fur look so soft. This blending also helps the body to appear rounded.

This close-up of the front fur area shows the blended edge. The breaks in the fur describe the length of fur.

Painting Animals Step by Step

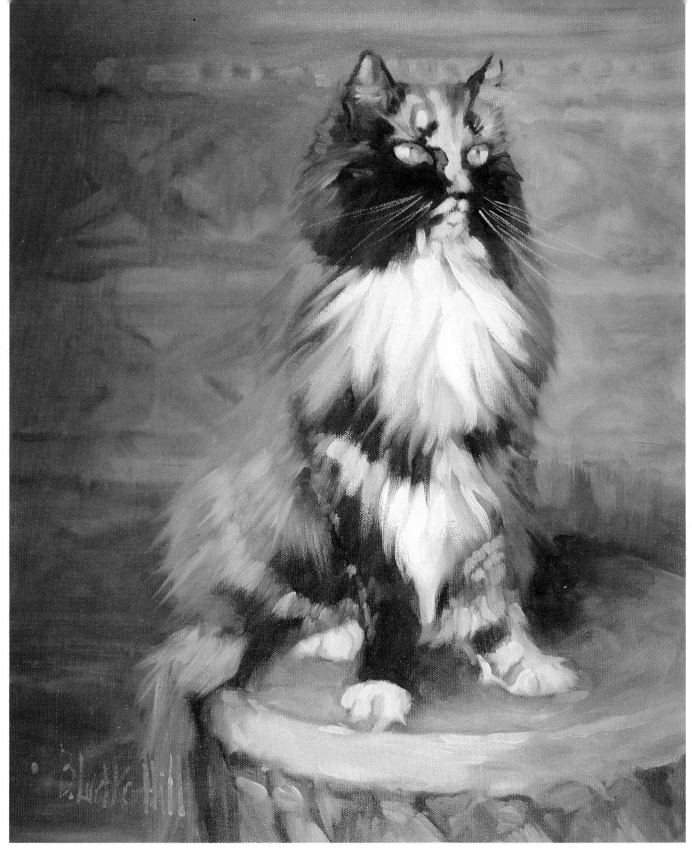

Patches, 20″ × 16″, oil

For the finish, I added the light colored fur, plus eyes and mouth detail. I moved her right eye in a bit, as I felt it was placed a little too far out; this is easy to do in oils. The whiskers were the last things I added when all else was finished. I painted them with a long-haired highliner brush.

Lone Duck

Painting Water and Reflections

Most towns and cities have a pond in a park or in the nearby countryside. This proximity provides great opportunities to sit and watch the antics of ducks and listen to their conversations. There's never a dull moment watching ducks on a pond; something is always going on. We had ducks as pets when my son was small, so I have a special soft spot in my heart for them. Each of our ducks had a very different personality and each one displayed his individual character in special ways. David was a mumbling companion. He loved being right with you, usually underfoot, talking in a low mumbling voice. Weed was never very tame and always kept his distance. Gablin thought he was a lap duck. He would greet you by flying or jumping into your lap and nuzzling your face or ear. He also was very vocal, carrying on his monologue in a loud voice.

In drawing ducks it's important to zero in on their basic structure — the oval of the head, the tubular neck and the almost trapezoid-shaped body. The back of the neck has angles in it; it's not a simple curved line. A good bit of a duck's body is hidden when it sits on the water, so it takes on a completely different shape.

The challenge in painting a duck on water is to paint its reflection into the water and to keep that area looking liquid and wet. This is achieved in watercolor by painting the water, the ripples in the water, and the reflection of the duck all at once. Although it may seem that there are too many things to think about and do at the same time, it can be done. I have more success if I can keep my paper wet while all of these parts are painted. The secret is not to let your paper dry. If it does, you'll get a hard edge and it will detract from the liq-

uid look. If dryness gets ahead of you, there's a way to soften those hard edges with a synthetic, flat bristle brush, a clean pot of water and a tissue. Wet the brush, then carefully tease the hard edges of the paint and blot with the tissue. The soft edges will come back. Be careful not to disturb areas that are okay.

For "Lone Duck," I chose a very simple palette of cadmium yellow, scarlet lake, ultramarine blue and manganese blue. The yellow and red make good oranges for that late afternoon orange glow. I chose the two blues to have a variation of blues in the water. I wanted to go through blue-green to blue to purple-blue. The oranges were a complement to the blues. I used the manganese blue rather than phthalo blue because the manganese blue is easier to lift back out.

This is a small thumbnail sketch, a simple plan of a lone duck on the water.

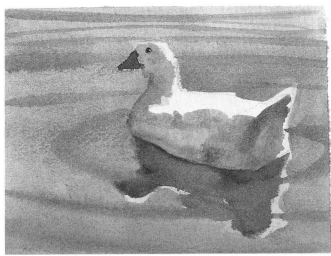

This color sketch shows the plan of complementing variations of blue with orange. Small amounts of yellow-green and red-purple complete the color scheme. The use of yellows and oranges in the duck and the water lends an end-of-day atmosphere.

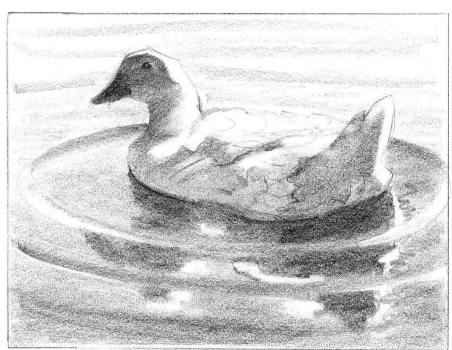

Here is a more detailed sketch of the duck on the water.

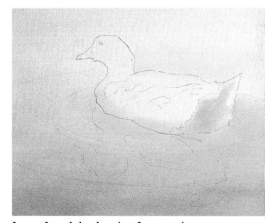

I transferred the drawing from tracing paper to the watercolor paper using the coin rubdown transfer method. Then using a 2-inch wash brush I applied a yellow wash all over the drawing. I increased the value of the wash toward the bottom of the paper and on the rear of the duck. I allowed the wash to dry.

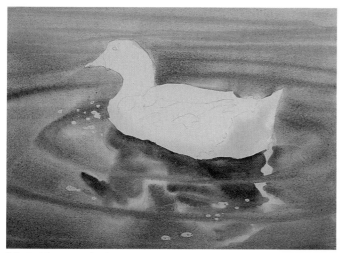

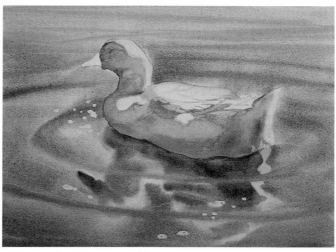

Maskoid was applied to preserve blank spaces to paint in floating debris. A blue wash was applied, graded from light at the top to darker at the bottom. Ripples and waves were painted into this wet wash in a still darker value. Also, the duck's reflection was painted while all was wet, painting around the light reflecting areas. This stage was allowed to dry.

Using no. 6 and no. 8 round brushes, I painted in the duck with light washes of yellow-green, blue, and grayed oranges, with the feather detail added to that. I took care to blend the colors for a smooth transition. I removed the Maskoid and painted the floating debris. Then I added the duck's eye and bill. Using a moist synthetic bristle brush and then blotting with a tissue, I lifted sparkles or lights on the water. I added feather texture on the duck.

This is a close-up showing the placid areas of the water. When the water is painted in several steps—in this case the yellow wash was laid down first and allowed to dry, then another wash was applied on top of that—it takes on a translucency. It gives the water a more liquid look. This shows those luminous layers, the floating debris, and the points where paint was lifted from the top of the wave.

This close-up shows the layers of washes. The light reflected yellow area is the reflection of the light on the tail; the dark reflection of the body was laid simply into that wash. The blue wash of the water was laid around the reflection. The wave is a stroke of blue color brushed through the dark reflection. Then the highlighted edge of the wave was lifted with a clean, wet synthetic bristle brush and blotted with a tissue.

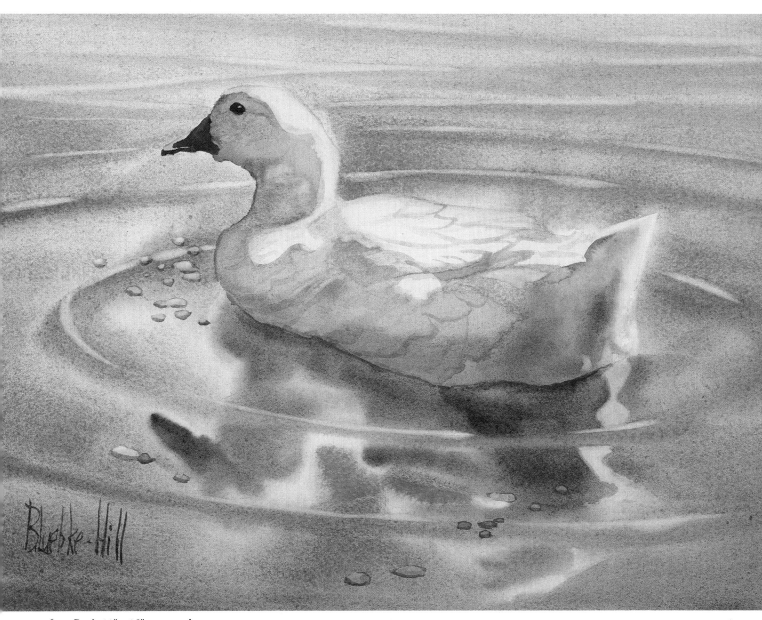

Lone Duck, 11″×15″, watercolor

Clydesdales

Painting the Light Sheen on Short Hair

The draft horse has come back into public favor after its rapid decline in the mid-1940s. That was a time when many farmers retired their draft horses and turned for power to tractors and other mechanized farm machinery.

The draft horse possesses a willingness to work, soundness, stamina and great strength. He can move large loads with an easy stride. There are five breeds of draft horses; the Clydesdale is the one I happened to see here in Tucson.

The Clydesdale comes from the Clyde River Valley in Scotland, near Lanarkshire. It is thought that its ancestry traces back one million years to a massive and powerful beast, the primitive *equus robustus*. Descendents of these large horses were used for war during Roman times and carried knights in the Middle Ages. In Europe, the great horses were gradually adapted to pulling plows and doing the heavy labor of farm work.

Clydesdales, known for their quiet disposition, are relaxed and patient. It's very exciting to be in the presence of these "gentle giants" with their majestic bearing and high-stepping gait. They carry themselves with ease and agility despite their great height and weight, which can be as much as one ton.

The legs and hooves of the draft horse are their foundation, so it's no wonder that these are their most important features. A small and narrow hoof would not be useful in a soft plowed field. I think the feathered lower legs are especially handsome. The feathering also serves as protection for the legs and hooves.

The special challenge in painting the Clydesdale is to capture the sheen on its coat. This sheen depends on the direction of the source of light, plus the horse's form and the direction of hair growth, that is, the hair tracts. The hair on a horse generally flows down and toward the back. The hair tract swirls are at the center of the forehead, the underside of the upper neck, the upper part of the front legs, the flank area, and the underside of the chest and belly. Knowing these areas in addition to the form will help you understand why there is a change of light.

These Clydesdales are just standing, so it's easy to position them correctly. If I were designing a painting with a walking or running horse, I would make sure its leg positions were correct. Earlier in this book I recommended that you use Eadweard Muybridge's *Animals in Motion* to study the way animals walk and run because it is so important that the action be drawn correctly.

The colors I chose to paint these Clydesdales were white, Winsor yellow, scarlet lake, burnt sienna, manganese blue and ultramarine blue. The yellow and red make rich oranges and red-oranges; the yellow and manganese make brilliant greens; and the yellow and ultramarine make subdued green mixtures.

I first did a thumbnail sketch to get the placement of the horses in the format, then a color sketch. My basic plan was to keep the painting quite simple. I drew the Clydesdales on separate pieces of tracing paper, then moved the drawings around until I was happy with their placement. I used this method to be sure there was plenty of room for the horses' bodies to be in correct perspective in the format. Next, I used the graphite paper method of transfer, described in chapter four, to place the Clydesdales on the canvas.

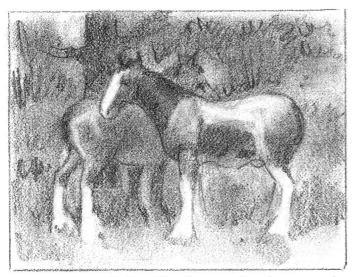

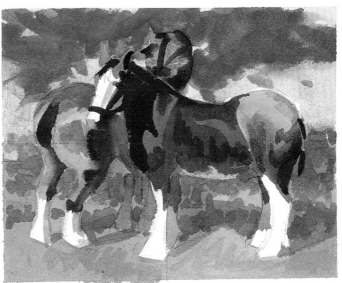

I wanted to feature the horses' legs, hooves and sturdy rumps, so I felt this placement might achieve that.

This color sketch features the nice, rich orange and red-orange mixtures.

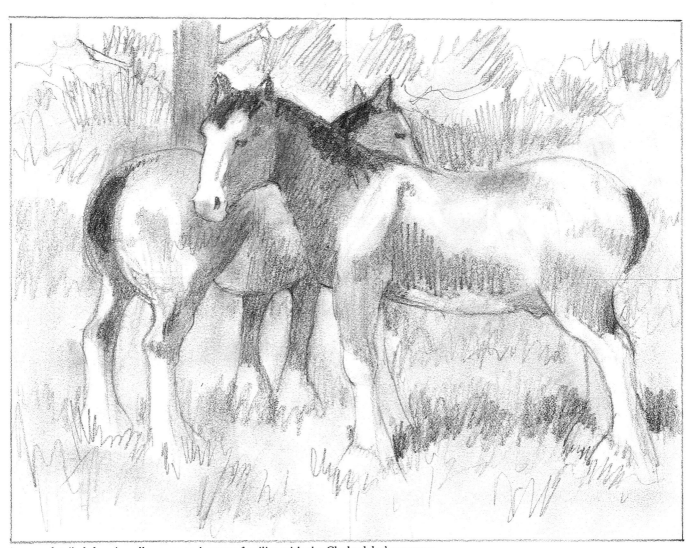

A more detailed drawing allows me to become familiar with the Clydesdales' structure.

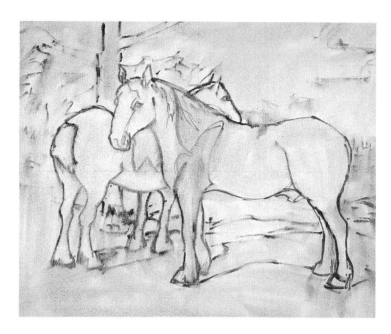

I redrew the Clydesdales with burnt sienna on a toned canvas, using a no. 2 filbert bristle brush.

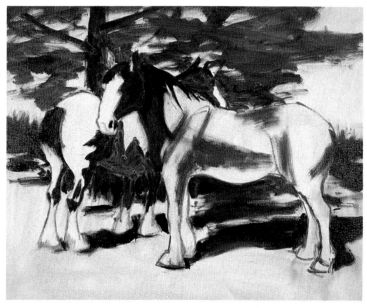

The darks, a mixture of burnt sienna, ultramarine blue and scarlet lake, were laid in on the tree, the shadows and the Clydesdales with a no. 6 filbert bristle brush.

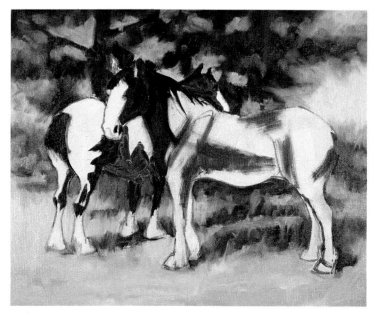

The greens and blue-greens of the tree, grass and background barn were laid in. The subdued greens were mixed using ultramarine blue and Winsor yellow; the more brilliant greens combined manganese blue and Winsor yellow. Both green mixtures have some scarlet lake in them to gray them.

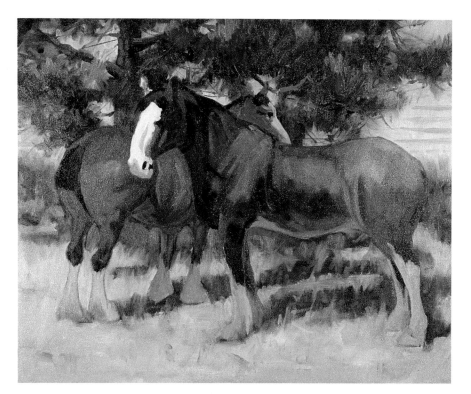

I painted the warm, dark oranges and yellows on the horses. These colors are mixtures of Winsor yellow, scarlet lake and burnt sienna. Many nice variations of yellows, oranges and reds can be obtained with these colors. I added the tree branches and more work on the tree and background. The white on the foreground horse's face is a mixture of Winsor yellow and white with some blue added for the shadow area.

I added the white legs and hooves and painted both the light reflected onto the horse's underside from the sunlit grass below and the background horse's face. I painted the reflected light on the horses' bodies but later, in the finish stage, changed it to a lower value; as pictured here in this stage it was too light. The reflected light needed to contain more of the local color of the horses. Reflected light is shown at places where the body makes a change in form or the hair tracts change direction. Notice the flank area where the hair tract makes the light change.

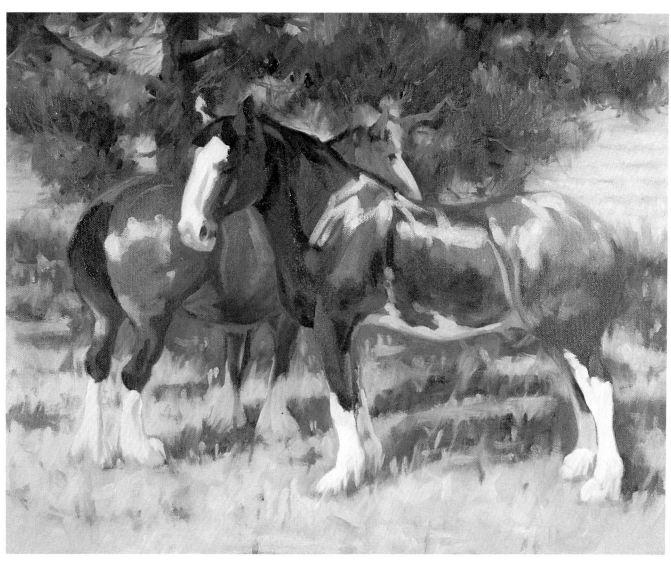

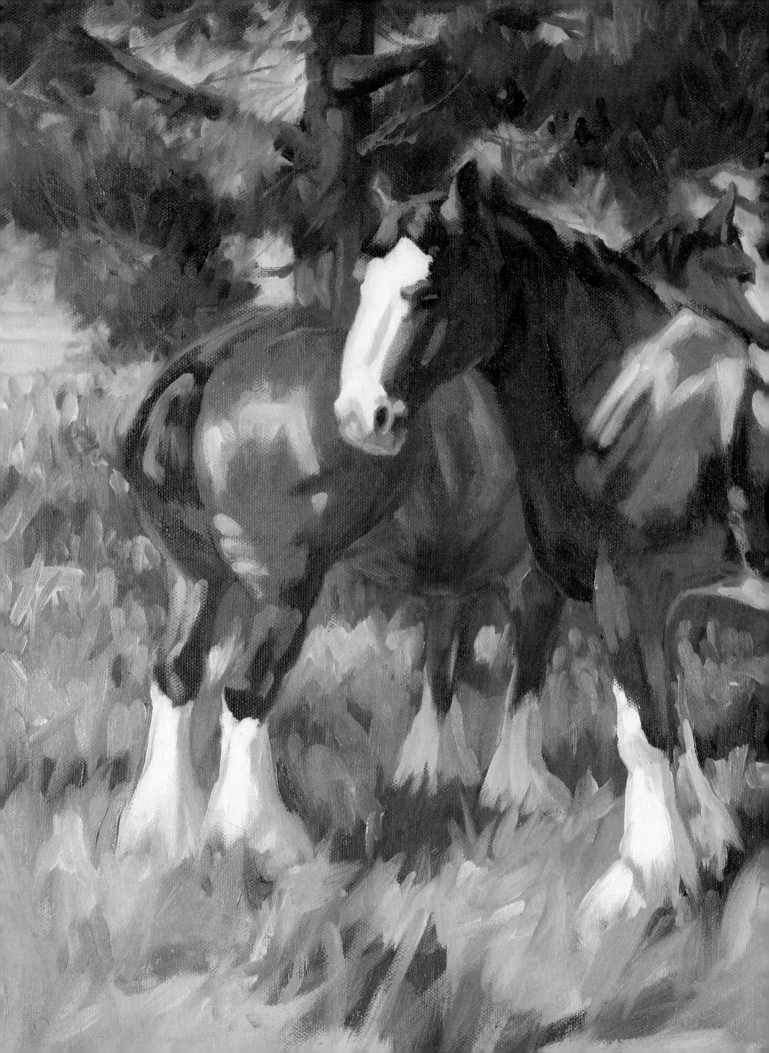

Clydesdales, 16″ × 20″, oil

To finish, I also added more of the feathering to the legs and feet. I darkened the grass area to help bring out these wonderful features.

Lop-Eared Bunnies
Painting Soft Fur in Watercolor

These mini-lop bunnies are the 4-H project of Angelika Kanizsai, a delightful eleven-year-old girl.

We drove about eight miles out into the country on a beautiful hot summer day to find Angelika and her bunnies. It was quite an experience to find the bunnies, happy as can be, basking in their own evaporatively cooled building.

The mini-lop rabbit was first found in Germany where it was called *kleine widder*. In America, they are known as mini-lops. They typically have a broad face with a pushed-in look, like a bulldog's. The best in the breed have a butterfly design outlined in white on their nose. Their front feet should be white and their back feet white or colored. The drooping ears should be well furred and well rounded. The mini-lops' color can be solid or broken. Angelika knew her rabbits, and I learned a lot.

I picked out three broken-colored bunnies to photograph—I felt it would be more fun to try and paint the varied color patterns on their bodies. I chose Marc, a black-and-white, who was a winner for Angelika at the fair; a gray-and-white, Robin; and a brown-and-white, which did not have a name because Angelika had just acquired it.

We had a great time taking shots of the rabbits; the nameless brown-and-white was the best at posing. He was such a good model that every shot was a good one. It was as though he knew he was supposed to sit still and not move. We started talking about what a sure shot he was, and Angelika said, "That's what I'll name him, 'Sure Shot'."

The bunnies were so cute I wanted to paint all three. So I drew detailed sketches of each one on tracing paper to final painting size. Then I tried several arrangements of the sketches, moving them around, overlapping them, and so on. It's a good way to try out the actual size and effect on the watercolor paper format. I came up with an arrangement that I liked and then did a color sketch to get a feeling for how it would look. The only change I made was to make the warm brown colors more predominant in the final painting, rather than the cooler purples and grays of the sketch. I kept the background simple as I felt a lot of texture or detail would take away from the bunnies. They seemed to have enough variety in themselves.

The bunnies presented a special problem in that I wanted them to look soft and cuddly. I knew that I had to use mostly soft edges to achieve this effect. It would be hard to keep the painting constantly wet while working on it, especially here in dry Arizona, so I planned to wet areas as I painted, after the first initial wet-in-wet washes.

I decided to use my three old reliable colors: new gamboge, alizarin crimson and ultramarine blue. The yellow and red would make nice rich oranges. I wanted to contrast these rich oranges used for Sure Shot against the subtle purples and darks of the other two. The other two bunnies are painted in values of grayed purples, but they are read by the viewer as black-and-white and gray-and-white, which is what they are.

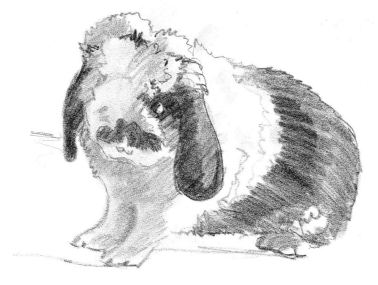

I worked in a little different direction in composing this painting. I did a detailed sketch of each bunny on tracing paper in the actual size that I wanted to use them. Then I moved the sketches around, overlapping one with the other, trying out different positions until I found a composition that I liked.

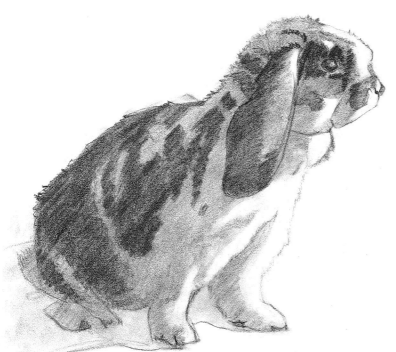

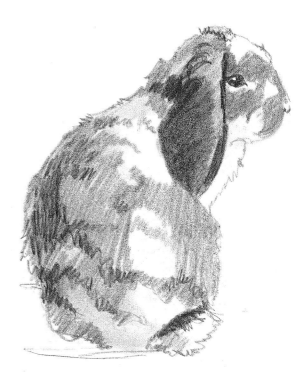

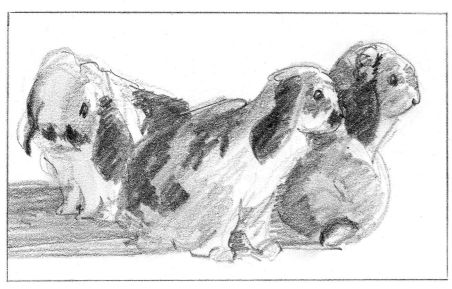

Then I did this small sketch of their placement to check how their bodies would fit with and overlap each other.

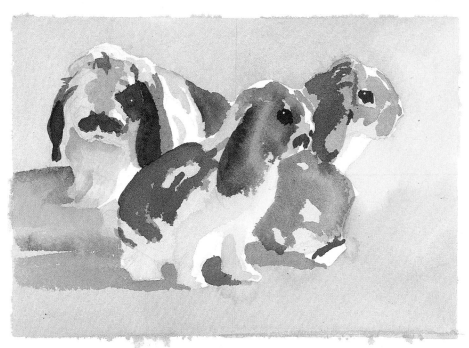

A small color sketch let me see how the juxtaposition of the colors of the bunnies would work.

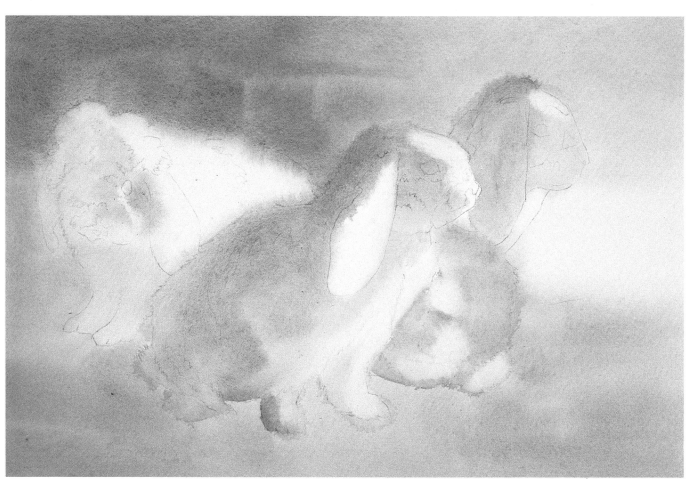

This shows the first wash of ultramarine blue, alizarin crimson and new gamboge, applied with my 2-inch wash brush. The purple wash was graded from left to right, blending into yellow on the right. A warm wash was put on the foreground area. While everything was very wet, pinks and warms were added to the bunnies' light sides and blues were added to their shadow sides with a 1-inch flat. White areas were painted around or lifted out with a sponge. This was all done wet-in-wet in order to keep soft edges.

Painting Animals Step by Step

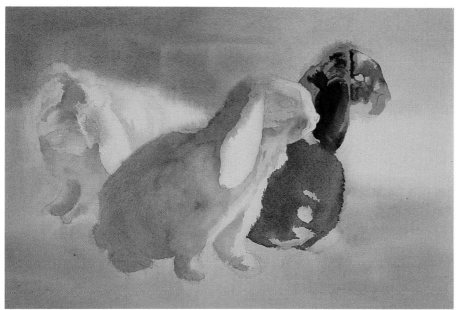

The next step was to add the first wash on the white fur areas of Marc, the left rabbit, and a shadow wash on Sure Shot, the middle rabbit, plus a dark wash on Robin, the gray rabbit on the right. Because the first wash was dry, these washes went on with hard edges. I painted these washes with a no. 8 round brush. As I paint from beginning to end, my brush size decreases so that the final details are painted in with the smallest brushes. Always remember to paint any stage with the biggest brush you can use.

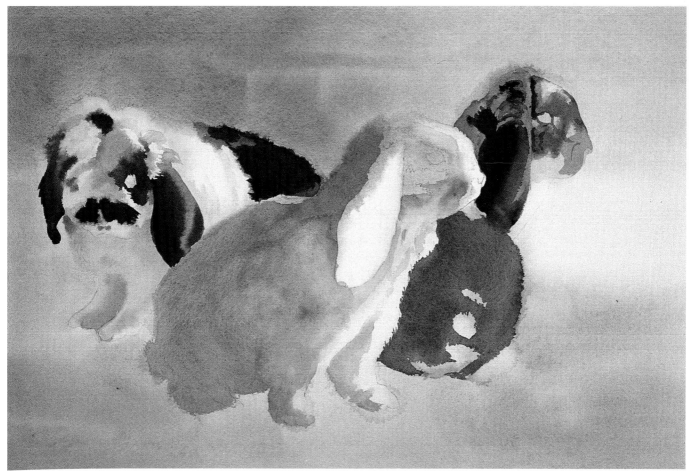

I put a second darker wash on Marc, on the left. I rewet some areas to get a soft edge with the dark paint.

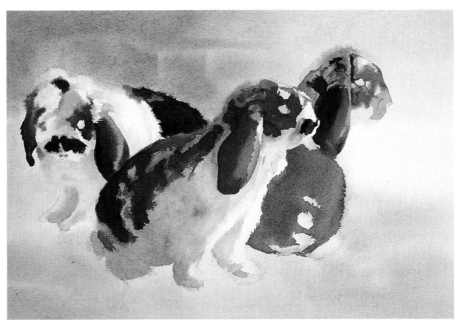

Next I added the dark orange color to Sure Shot, the middle bunny. Some of the edges of the orange color were wet and some were dry.

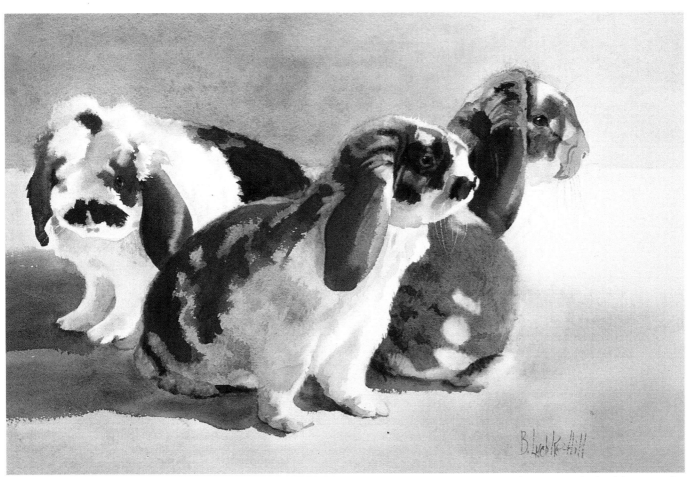

With a bristle brush and clear water, and using a tissue for blotting, I lifted and softened certain areas. Then I went back with more paint into other areas that needed darkening. I finished the faces and eyes and painted in the shadows of their bodies. It's important to be accurate in painting the eyes as they are the part of the body the viewer will look at first. I suggested the irises and pupils and added the sparkle to give the eyes life. At the end I felt the background was too purple and needed toning down to a warmer color, so I put on an orange wash.

Painting Animals Step by Step

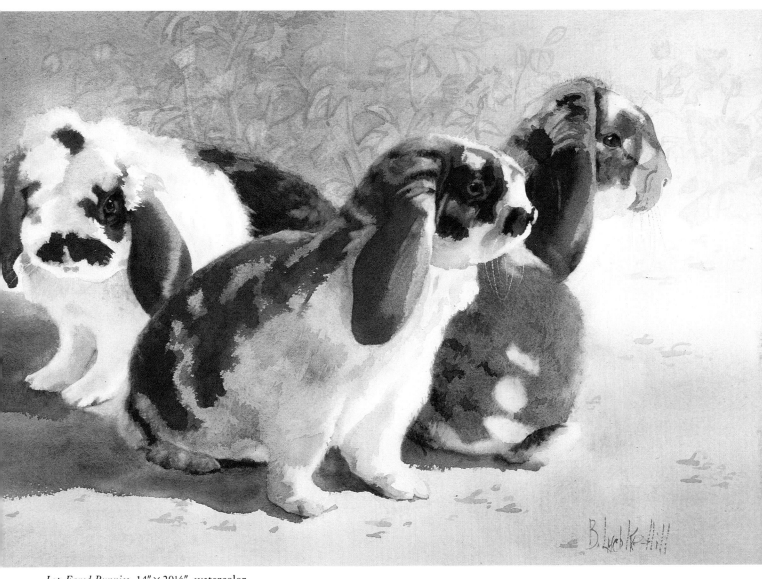

Lop-Eared Bunnies, 14″ × 20½″, watercolor

In the final stages of finishing I worked a suggestion of a flower garden in the background. I repainted Marc's eye, softened more edges and put a reflected light glow on the left side of the bunnies.

Jake
Capturing a Dog's Personality

To my mind, Jake is everything a dog should be. He's lovable, a great companion, and has a good disposition and personality. He wants to please, and he obeys the best he can.

Jake, an Australian shepherd, belongs to my daughter and her husband. They live in the country, where Jake thoroughly enjoys the mud, water and dirt. They went to a lot of trouble to make him presentable for this portrait. After cleaning him up and brushing him, they brought him into town for a photo session. When I saw him, he seemed very pleased with himself. He had had a bath and he knew he looked good. The painting in this demonstration was done from the photos I took of him during his brief visit into town.

Jake laughs or smiles with his mouth open most of the time, but I chose a more sober, mouth-closed attitude for this portrait. The feeling I wanted in the portrait was the look of trust that is expressed in the eyes of a dog. Since Jake naturally has that look of trust, it's important in capturing his character. That look is such an inscrutable thing, it's hard to put your finger on what accounts for that effect. Is it the fact that he is looking at you? Is it the calm in his face? It must be a combination of those things and possibly others.

Painting Jake created a special problem in that he is almost all black.

It's fine to paint his coat black, but in that blackness I had to show his form and the texture of his hair. It was important to show the rough quality of his coat. His hair sticks out in all directions and lies on his body in a casual, mussed-up way. I chose to do his portrait in oil because I felt it would be easier to paint this characteristic of his coat in oil.

I decided to handle the portrait as a vignette. I chose only white and four other colors: cadmium yellow-medium, burnt sienna, alizarin crimson and ultramarine blue. I used the last three colors because they make such beautiful dark mixtures. They are dependable, workhorse colors.

For the thumbnail sketch, I did this small vignette.

The first step was to do a pencil sketch of Jake to familiarize myself with Jake's face and head.

I wanted a fairly factual portrait colorwise, so I chose white, cadmium yellow-medium, burnt sienna, alizarin crimson and ultramarine blue. These last three colors make great clear darks and can be adjusted toward warm or cool.

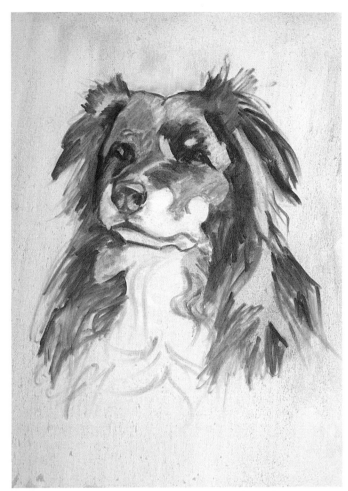

Using burnt sienna only, I placed a value sketch on the canvas. Using a no. 2 (¼-inch) filbert brush, I started with a gesture sketch, roughing in the dog's head, then carried it further with light and dark values of burnt sienna.

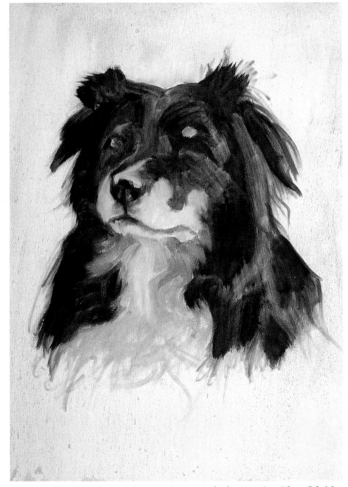

Mixing alizarin crimson, burnt sienna and ultramarine blue, I laid in the very dark darks with a no. 6 (½-inch) filbert brush. I painted the darks in the shadow areas on Jake a warm dark, which seems to go back in, as shown between Jake's head and ear, whereas a cool dark gives the impression of reflected light from outside sources. I also added the warm oranges and soft, light-valued hair on his muzzle and throat. At this stage the painting was handled very roughly and kept loose.

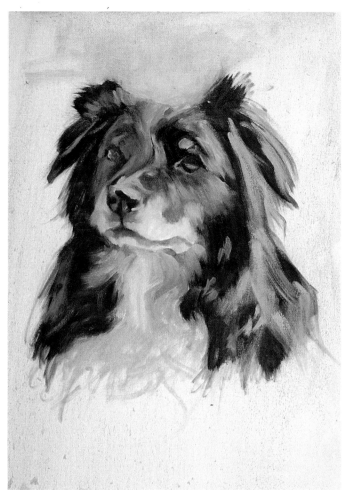

A blue mixture representing the light glistening on his coat was added, keeping everything quite tentative. This lighter blue color is actually the part of his form (the black hair) that is reflecting the light of the sky. This made it stand out from the warm dark going into the shadows. I painted in the brown of his iris catching the light in his left eye. The top of his head was built up too high, so I brought it down a bit.

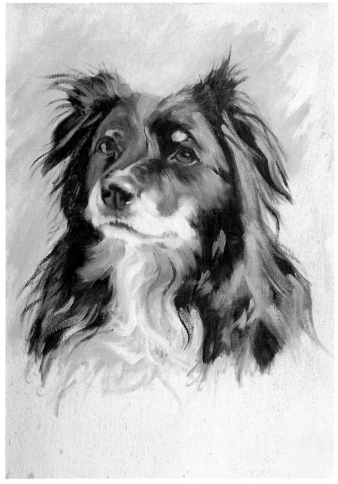

Detail was added in both eyes, and more detail was painted on his nose and muzzle. The white hair on the chest was added, plus all of the wild hairs sticking out in all directions. The hair right under the muzzle was darkened to make the throat go back and the muzzle come out.

A close-up of the hair texture shows rough brushstrokes to depict the hair. Long continuous strokes work well in showing hair with length.

The left eye was moved in a bit and the right eye reflection made less dominant. Remember to paint the eyes differently. Nothing is more boring in a portrait than two eyes painted the same. Note the shadow area caused by the eyelid, the light shining on the bottom area of the iris, and a small dot of light paint for the glistening light on the eyeball. That dot is usually painted with a light or light middle-value of a color or an off-white. Don't use pure white paint as it will pop out too much.

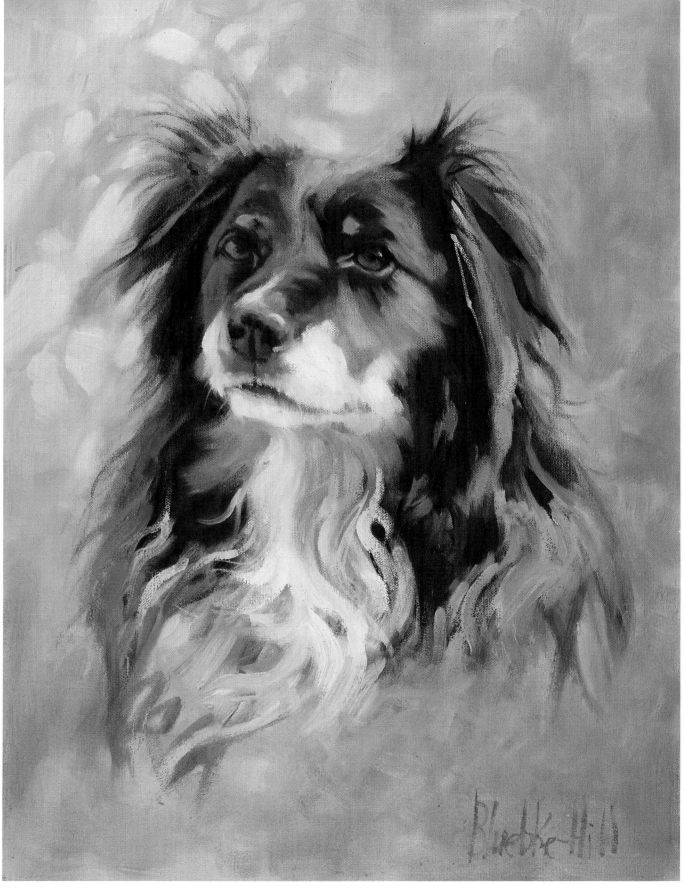

Jake, 18″ × 14″, oil

In the final adjustment, I changed the background from cool to warm, as this gave the painting a better overall feeling and unity. To make the background more interesting, I lowered the values of the colors in some areas and raised them in others. Also, I brought the left side of Jake's chest down toward the frame line, as this made a better lead-in.

Geese

Painting Soft Feather Textures in Oils

I like geese. I guess it's their stately stride and carriage that impresses me. They seem to demand respect.

Whenever I want to paint geese, I go to our local park. There are several varieties there, plus crossbreeds, some of which have interesting combinations of body colors and features. The geese found in local parks are generally quite gentle natured, but be advised that a few can be cantankerous. If you look for geese on a private farm or at someone's home, you're more likely to come across birds that are very territorial. Strangers are usually not welcome. We had geese on the farm when I was a child, and I can remember how big they always seemed; I usually gave them plenty of room. So, be alert.

If you watch geese for a while you can usually figure out their social structure. They are generally monogamous, and pairing couples are easy to pick out. The gander is quite demonstrative in protecting his lady

and later his brood. He stretches his neck, either straight up or thrust forward, hisses, nips, and beats with his wing shoulders (anatomically equivalent to our wrists). Geese also have an established heirarchy. New arrivals have to find their position in the group's pecking order.

In an earlier chapter, I talked about the differences between ducks and geese. These differences should be obvious in your paintings so your viewer will not be confused. The goose has a longer and heavier neck (remember the angles or corners in the neck—it's not a smooth curved line); a heavier bill without the concave swoop of a duck's bill; a heavier body in more of a triangular shape (sometimes with a paunch); and usually more feather texture in the neck.

The colors I chose were cadmium yellow, alizarin crimson, phthalo blue and white. I wanted to slant this painting toward red, even though the red is subtle and grayed down. Using phthalo blue with alizarin

crimson was a natural choice as the yellow in the phthalo blue tends to gray the mixture. I strove for a predominance of reds from cool to warm, complemented by the cool color of the pigeons. The reds were cooled with phthalo blue and warmed with cadmium yellow. The whole palette was grayed and reduced in value to enhance the light color of the geese.

The problem I wanted to solve was how to paint feathers and make them appear soft. I knew I would have to use very subtle color and value changes. You can see these subtle changes when you look closely at the feathers. The colors were kept very close. This gives the effect of the dimpling of the feather surface as it catches different light. The change from one color to another was done gradually, with soft edges. I felt that a softness in the whole painting, including the grass area, would create unity and help to solve this problem.

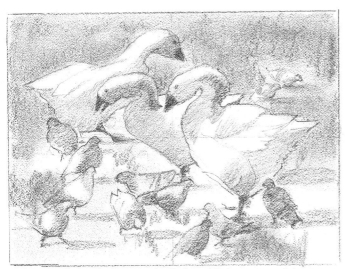

A thumbnail sketch gives me the dark and light pattern of the geese and the pigeons.

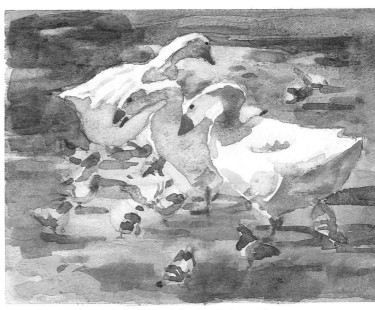

A small color sketch shows the subdued coloring with a predominance of reds and oranges.

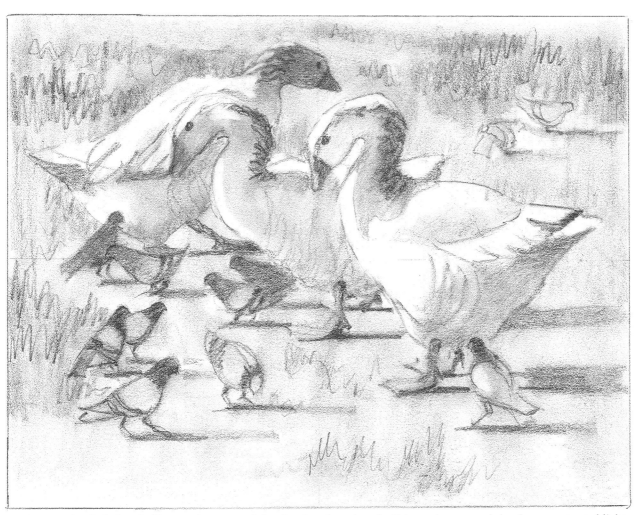

In this more detailed plan, I silhouetted one goose's head and neck against the light, and two geese's heads are contrasted light against the middle-value background.

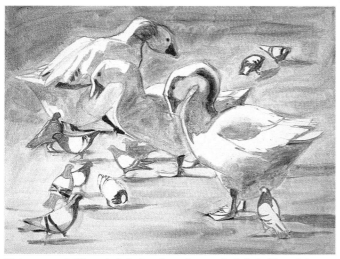

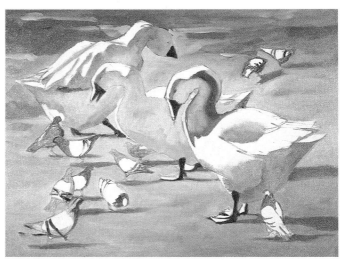

Using a no. 2 filbert bristle brush and grayed phthalo blue, I drew in the composition. I thinned this grayed blue color with turpentine and added a thin value wash over the canvas.

Using a ¾-inch filbert, I mixed a red-purple and brushed in the background color. The values were kept dark at the top with some greens added. Coming down to the foreground, I gradually changed the color to grayed oranges. I added the first subtle colors to the shadow areas on the geese and painted the cast shadows.

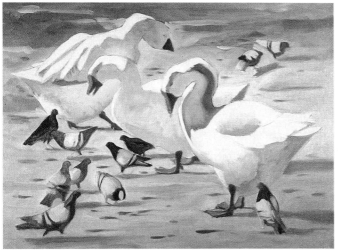

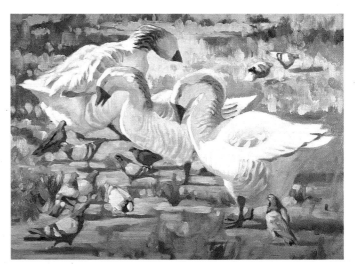

I continued painting a flat pattern on the geese, pigeons and background, and kept the painting quite loose. I added the lighter, warm yellow-orange to the sunlit areas on the geese. I painted in the flat dark and light patterns on the pigeons. Then I added the bright oranges to the feet and bills of the geese and some texture on the ground.

The white feathered areas were painted on all of the geese. In order to make the texture seem like soft feathers, the value differences were kept very slight. Hard edges or too much contrast would have ruined the effect. Some feathers or groups of feathers were outlined with slight value changes to show the feather form. In real feathers there is a slight coloration. These coloration changes were kept light in value in the painting. Notice the turned-in area of the wing on the foreground goose. The value of the feather texture is increased as it goes into the shadow area. Notice the cores of the shadows (darker) and the reflected light in the shadow areas. This is light reflected from the ground. The dark textures in the necks of the geese were added. The pigeons were painted in with cool colors. Some of the iridescence of their feathers was added. Grass texture was brought out in the foreground and background.

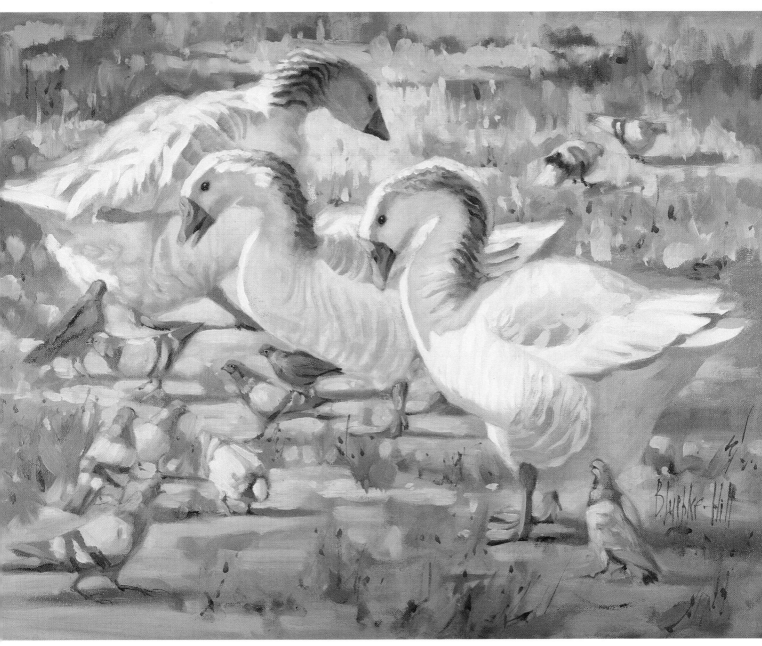

The Gleaners, 18″ × 24″, oil

In the final stage, all of the detail on the eyes, bills and legs of the geese and pigeons was painted. The dot of sparkle (not white paint) was added to the geese's eyes. More grass texture was added. I decided that the head of the goose in the rear was too big, so I trimmed it down a bit.

Charlie and Patches

Painting Pets in Filtered Sunlight

When you see your pet cat every day, you see it in all its moods and postures. You can almost predict your cat's behavior as your familiarity increases. From time to time you will catch your cat in a pose or mood that inspires you to paint, to preserve the memory of that pleasing moment with all the heart, soul and excitement that you feel. This is the feeling I often have just watching my cat strike her never ending series of poses.

Patches is a long-haired calico. She was a desert orphan who decided to adopt us. Her job is to keep the pack rat population under control in the yard. She takes her job very seriously and is certainly worth all of the care and love we give her.

In this painting Patches was joined on our front porch by our neighbor's cat, Charlie. The sunlight was filtering in on them, flooding them with light and producing a warm, dreamy atmosphere. I wanted to reproduce their trancelike state while they were basking in the sun. The challenge for me was to create this mood. What would give me a warm, dreamy feeling?

To obtain that warmth I decided to emphasize yellows and oranges in the painting. A dreamy feeling, to me, says vagueness, softness and lost edges. Shafts of light, fading out the color, add to the effect. So I decided to do the painting in watercolor because the wetness would give me plenty of opportunity to achieve those lost edges. Plus, the wetness would help me create a soft fur effect.

I took several photos of the pair to capture their attitude while in this dreamy condition. I knew that they wouldn't stay in those poses very long. Now I had the shots as backup reference.

I did plenty of sketching to learn more about their anatomy. I did detailed sketches of a cat's eye, ear and nose, similar to those shown in chapter three. Understanding the structures of those parts is essential to making the final result convincing. When you put an animal in a painting, the viewer's eye will go to its face. Because of this, the anatomy of the face must be correct; some of the other parts of the body can be rendered a little more casually.

I drew the two cats onto tracing paper in the same size I wanted them in the painting. Then I used the coin-rub method to transfer to the watercolor paper. First I turned the tracing paper over and went over the lines with a 6B pencil. Then I reversed the tracing paper and positioned it right-side-up on the dry watercolor paper where I wanted to place the cats. With a coin I rubbed over all of my sketch lines, and the image was transferred right where I wanted it. It's an easy method of transferring sketches, and it doesn't damage the paper if you rub with only moderate pressure. This method of sketch transfer is illustrated in chapter four. I finished drawing in the other details of foliage, pot and porch.

I chose new gamboge, burnt sienna, alizarin crimson and ultramarine blue to emphasize the yellows and oranges. The blue was used only for graying colors and a slight bit of cool contrast for the warm colors.

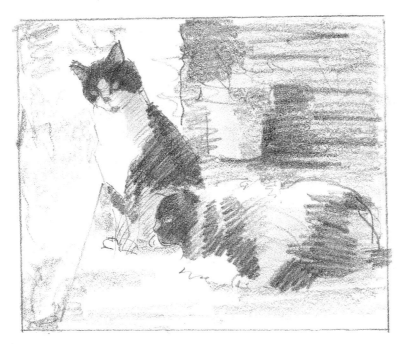

First, I penciled a small value sketch of the cats in the positions I thought would give me the feeling I wanted. I wanted to lead the viewer's eye in from the lower right to Patches in the foreground, then drift left and upward to Charlie's face in the upper left. I felt that this area of Charlie's face would be the center of interest.

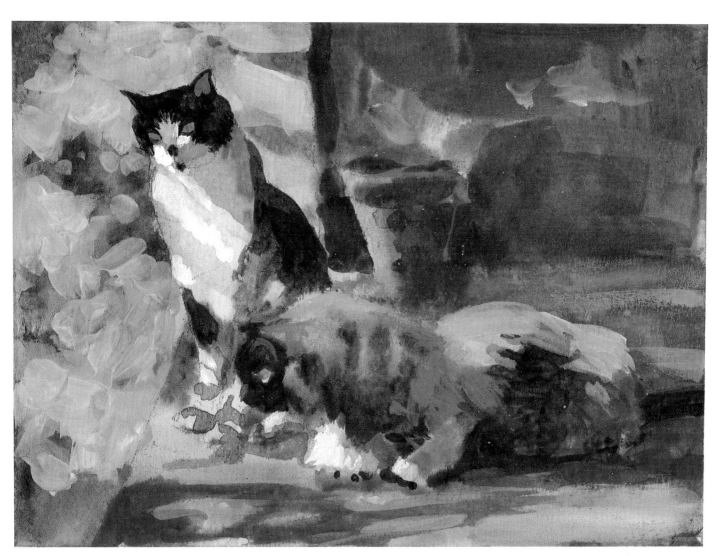

Next, I made a small color sketch to decide on my colors. I wanted the feeling of warm afternoon sun adding to the softness of their fur and the softness of the light. The light shafts to the right and downward help bring the eye back to Patches.

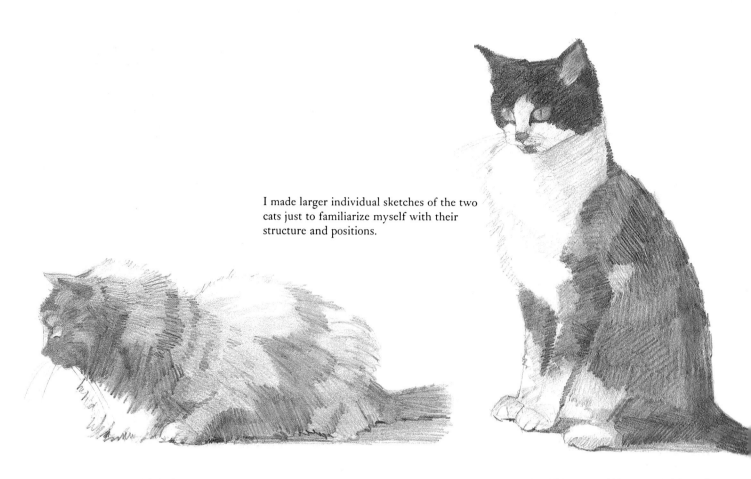

I made larger individual sketches of the two cats just to familiarize myself with their structure and positions.

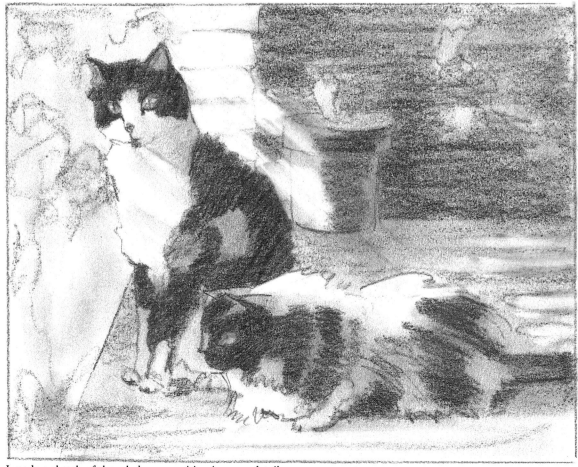

I made a sketch of the whole composition in more detail.

Painting Animals Step by Step

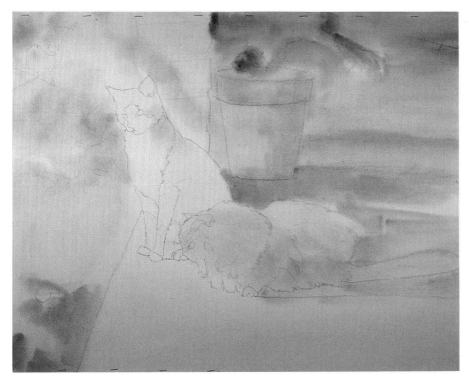

I transferred the drawing to the dry watercolor paper by the coin-rub method. Then I wet the paper thoroughly, letting it sit for a few minutes to expand. When I felt it had completed its expansion I stapled it down. Using a 2-inch wash brush, I brushed on an overall yellow wash to give the feeling of sunshine. I increased the yellow in the foliage area, on the cats, and on the porch floor then added reds and cool violets in the background and shadow areas.

While the first wash was still wet, I went quite a way with darker values because I wanted to maintain the soft focus of streaming light. So at this stage I put in the back wall, the shadow patterns on the floor and the outside foliage. I used a 2-inch wash brush for the large areas and switched to a 1-inch brush for the smaller areas. Also, I painted in both of the cats so that I would have soft furlike edges on them. Watercolor, when used wet in wet, is a great medium for depicting the softness of fur. Then I let the whole thing dry.

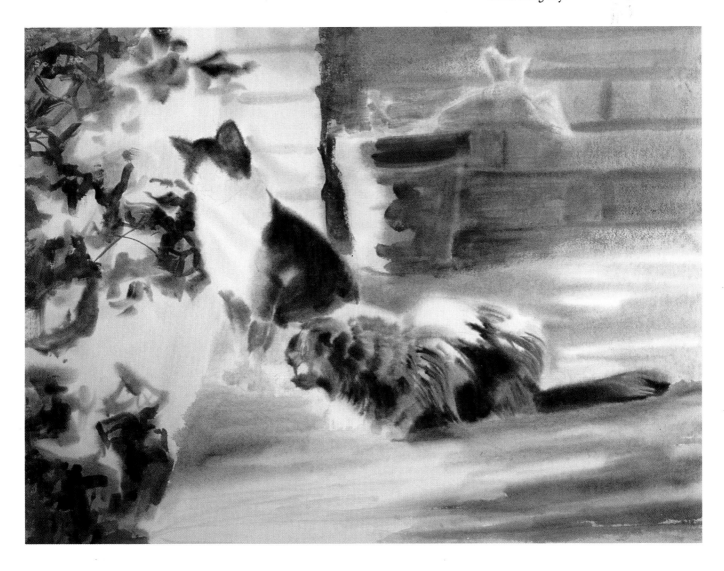

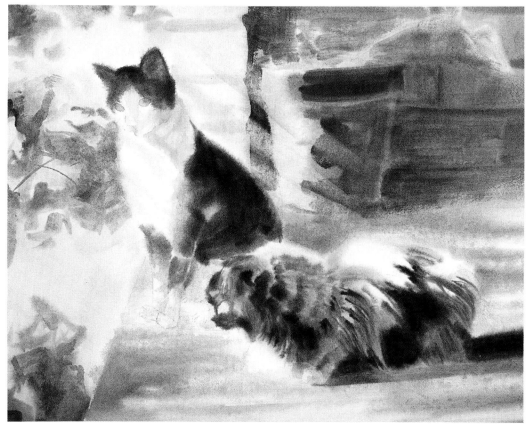

In some of the larger areas where I felt I wanted lighter values and softer focus, I lifted out some color with a damp sponge and blotted with a tissue. In smaller areas I lifted paint with a wet bristle brush and then blotted with a tissue. I especially concentrated on lightening the foliage, as I wanted a more diffused look, and lifted some of the light rays in the background. I painted in the cats' eyes, facial structure and shadows. Then I decided the painting would improve if I cut it down in size. By not using so much of the background area, I made it a more intimate painting. Don't be afraid to make major adjustments at any stage if it will help the painting. I went back in and painted more foliage in the light areas. I made the back wall darker and completed the shadow pattern on the floor. Most of the cats' edges were kept soft; the harder, crisper edges were reserved for their faces.

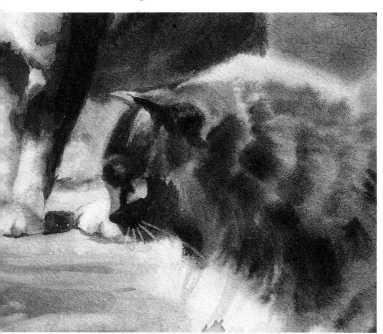

This close-up of Patches's face shows the completion of eye area, ears and addition of whiskers.

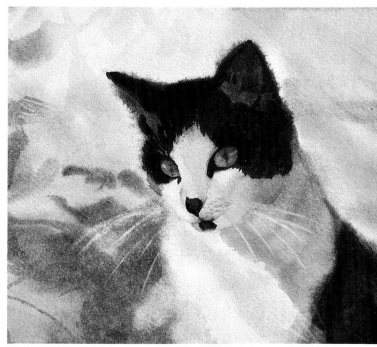

Whiskers were added to Charlie's face, too, and the dark fur completed in the face area.

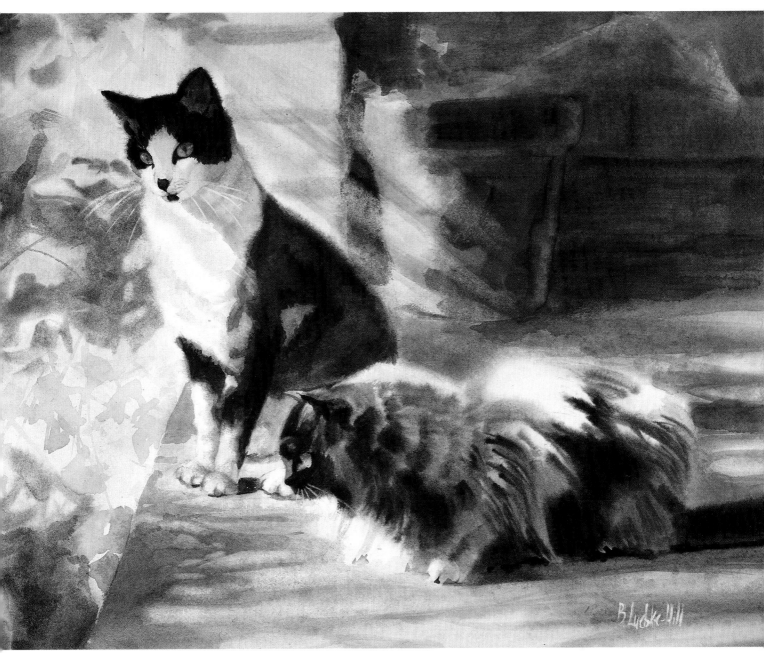

Charlie and Patches, 17″ × 22″, watercolor

Dairy Cows
Making Black-and-White Animals Colorful

A warm, late afternoon in the dairy pasture—that's the feeling I want! This group of dairy cows lives right in town, not far from my home. The university's agricultural farm provides numerous opportunities for animal painting. These cows are part of their dairy herd.

There is something very peaceful and bucolic about walking into a barnyard where there are cows. They are generally very quiet, just standing or lying around, not doing anything more important than chewing their cuds. Most of the time you are quite safe walking or sitting right in the pen with the cattle. But before you do this, check with the farmer or handler just to make sure you're not in some cantankerous bull's territory. I have often painted around cows and have found that they are very curious. I have had them make a ring around me, just watching what I was doing. It gave me a funny feeling, however, since they are such large animals.

Drawing cows on location is easy, as their movements are so much slower than those of most other farm animals. Note the differences in cows and bulls. Bulls are heavier and stockier, especially in the front quar-ters, than the bony, angular cows. Also, dairy cattle look bonier, their pelvic bones more protuding, than the heavier beef cattle.

Cattle are cloven-hoofed and have two smaller hooves behind and above the main pair on the back of each leg. Their ears are set lower on their heads, compared to horses' ears, and they are broad, rounded and generally covered with thick hair.

Cows lie down by bending their forelegs at the wrist and letting themselves fall to the ground. The reverse is true in getting up; the rear end comes up first.

After doing sketches of different cows, I came up with the plan for my painting shown in the thumbnail sketch. I wanted the viewer's eye movement to start from the lower right, move diagonally upward to the upper left, across to the upper right, and back down to the lower right.

I wanted this painting of dairy cows to give a feeling of repose and relaxation. I tried to express the sen-sation of warm laziness in the sun-light and cool crispness in the shad-ows—that's so often the feeling one has here in the desert.

The color sketch shows the warm feeling of late afternoon. I also planned to make a colorful piece out of a subject that was black and white. How could I communicate "black-and-white cows" and say it with color, while relating the time of day and temperature of the air? I felt I could best accomplish all of this through my choice of colors and, of course, how I used them. I chose Winsor yellow, scarlet lake, burnt si-enna, ultramarine blue plus white. The Winsor yellow combined with scarlet lake makes a good orange, slightly grayed because of the hint of blue in the yellow. The scarlet lake and ultramarine blue make a nice purple. When this is slightly grayed with yellow, the result is a good dark grayed purple, which was used for the black areas of the cows. The same mixture of blue, red and yellow lightened with white makes a soft grayed purple for the light hair area. I think purple and yellow-orange combinations are very exciting be-cause they are close to being color complements. The yellow and blue mixes for green didn't matter a great deal as there was going to be only a touch of green in the painting.

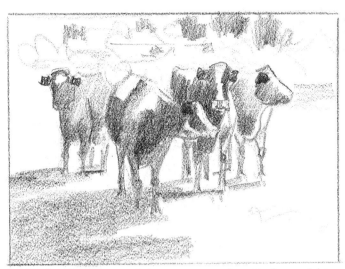

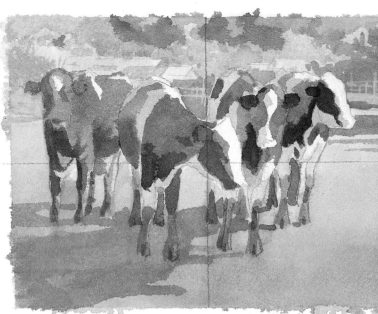

In this thumbnail I wanted the eye to move from the lower right, diagonally upward to the upper left, across to the upper right, and then down to the lower right. The background would be subordinated to the animals.

A color sketch portrays warm, brilliant light and cool shadows on the cows. The cows will be painted more intensely, the background grayed and subdued. In this way the cows will be featured and the background won't compete with the main subjects.

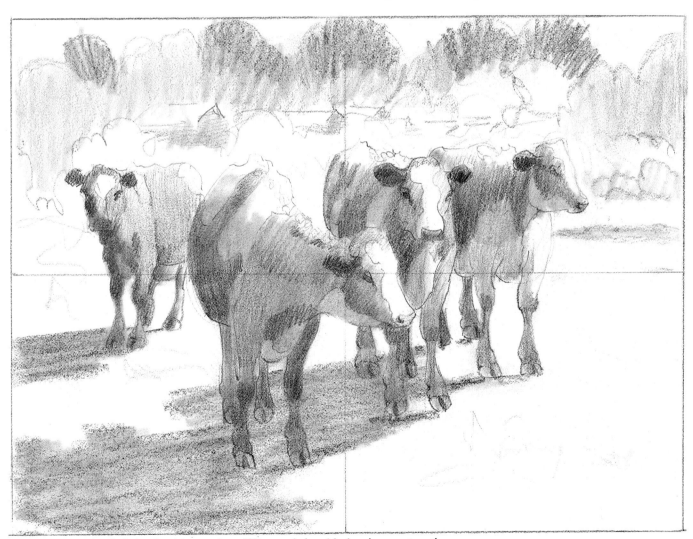

This is a more detailed sketch with squaring off lines to help with the placement on the canvas.

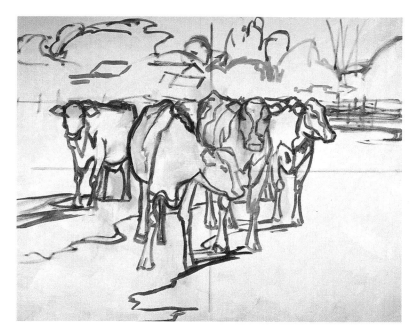

Using a no. 2 filbert bristle brush, I drew the subjects on the canvas with burnt sienna.

Switching to a no. 6 filbert bristle, I laid the darks in loosely. These darks were mixed with scarlet lake, burnt sienna and ultramarine blue. I used Liquin to thin my paints to give them a more buttery consistency, which helps the brushing slide more smoothly. Liquin also makes the paint surface dry faster, so I could continue to work on a piece without waiting for it to set up.

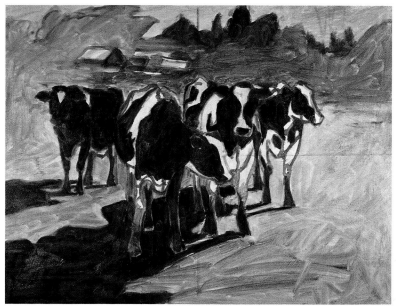

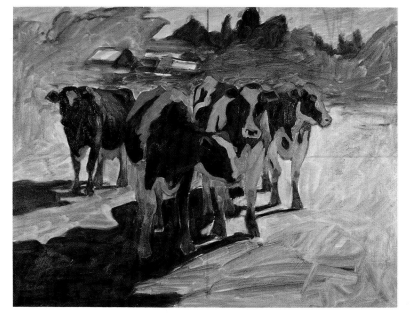

I painted into the dark areas of the cows, varying the colors and values slightly to indicate form. Next, I painted the white areas of the cows using variations of a middle grayed purple—cool in some areas, warm in others.

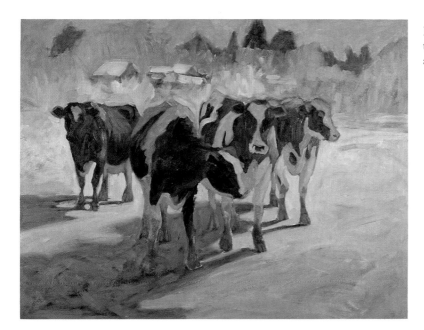

I laid in the first background colors to unify the painting, using light values of oranges and yellows.

I finished most of the background and foreground areas using no. 2, no. 4 and no. 6 filbert bristle brushes. The tree trunks were painted with a highliner brush. All of the background was kept subdued in order to feature the cows.

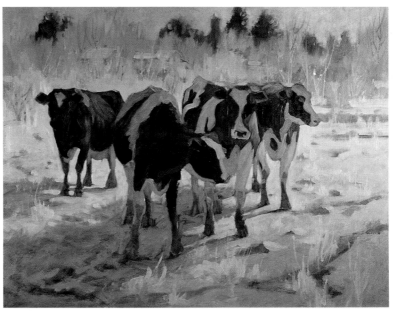

I painted into areas of the cows again, refining some of the detail. Note that the white areas on the shadow side of the cows are a darker value than the sunlit ground. Also the sunlit sides of the black areas are a lighter value than some of the white areas in shadow and the area of shadow on the ground.

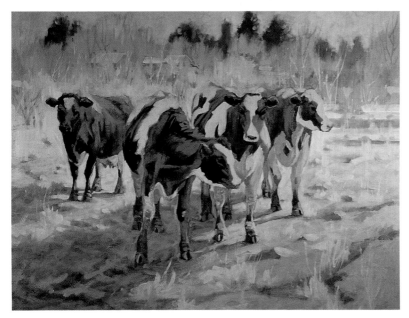

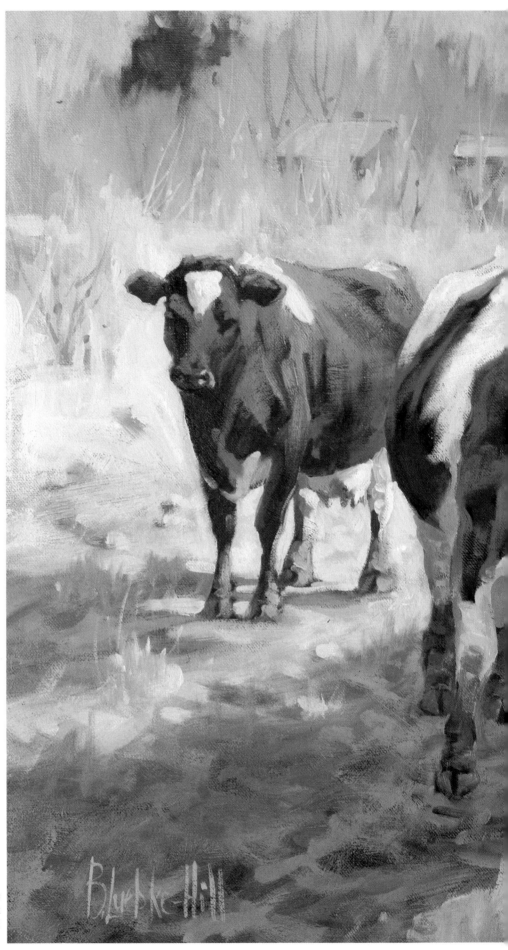

Tucson Dairy Cows, 18″ × 24″, oil

To finish the painting, I added the lightest color to the white areas of the cows where the sunlight spotlights them. The cows were painted entirely with colors; there is no black or pure white on the canvas. Yet the eye will read them as black-and-white cows.

Painting Animals Step by Step

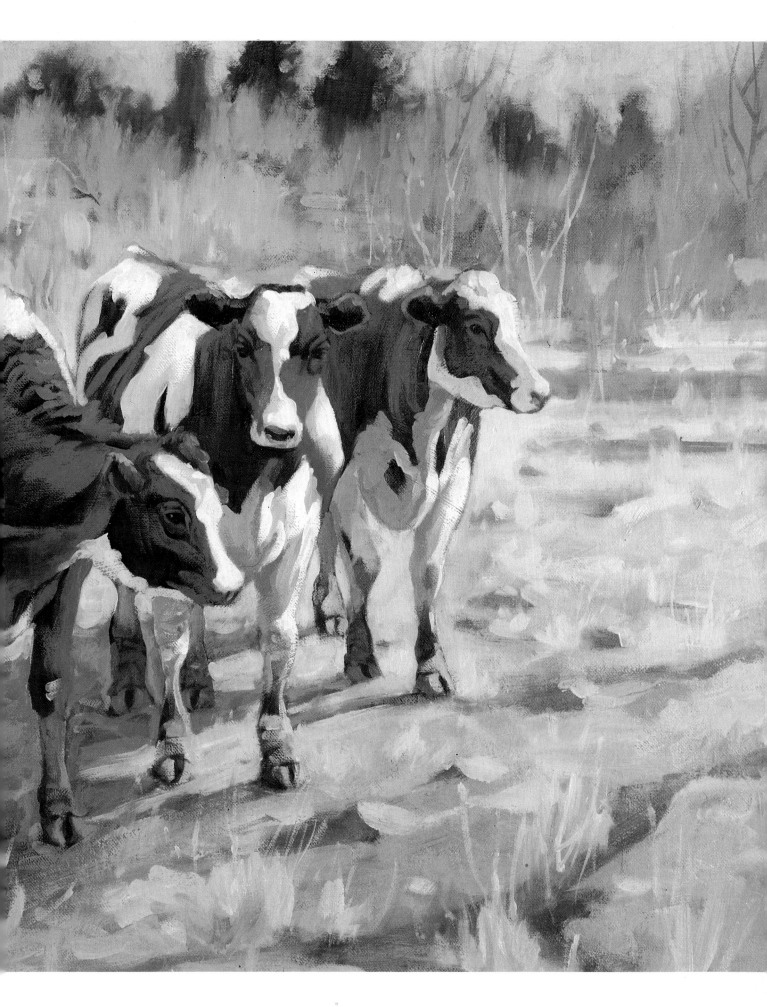

Barnyard Sheep

Rendering a Sunny, Tranquil Mood

I have always enjoyed seeing and being around sheep. I've tried to analyze why I get this good feeling and I think the reason's partly visual and partly the character of the beast. Visually they have such nice soft shapes, and their light color is almost always in contrast to their environment; they lend a quiet pastoral effect to any scene. Because they are white, or mostly light, their coats can reflect many of the surrounding local colors. If the sheep haven't been shorn, it's important to depict the texture and depth of their wool by indicating breaks in the wool. As to the character of sheep, they are docile and quiet and require guidance; they seem helplessly dependent on us, or on the sheepdogs that guard them. It's an additional challenge to portray their attitude of complacency.

I made a small black-and-white thumbnail of the arrangement to see if the composition I had in mind would work out. I wanted a directional movement from right to left with the center of interest being the group of sheep in the upper left. Then the slanting boards of the shed lead you back to the right. The chickens are spots of interest to carry the eye into the lower right foreground area to keep the movement going. I felt that using diagonals would keep a more dynamic feeling working throughout—a plus for the painting, as the upright posts lend a more static impression. Then I did a small color sketch emphasizing barnyard colors.

Here the special problem was to capture the mood of the sheep, the setting, and the time of day. I wanted to re-create the feeling of a warm lazy afternoon—almost motionless, with a quiet acceptance of time and place. The positions and stances of the sheep express their complacent attitude. The chickens add interest, plus some movement where there was virtually none. The tumbling down feeling of the old shed adds to the atmosphere and moment in time.

The colors I chose for the painting were cadmium yellow, permanent rose, burnt sienna and ultramarine blue. I wanted to make burnt sienna the predominant color, as I thought perhaps this color would give the painting subject a barnyard feeling.

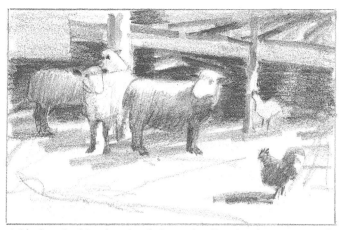

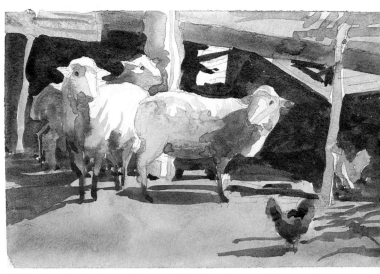

A black-and-white thumbnail shows the directional movement of light from lower right to upper left, to the sheep, which are the center of interest. The boards of the shed move the eye back over to the right. The chickens draw the eye down to the lower right.

This color sketch shows the overall feeling of warmth I wanted, with yellows and oranges predominating. A small amount of complement was used for excitement.

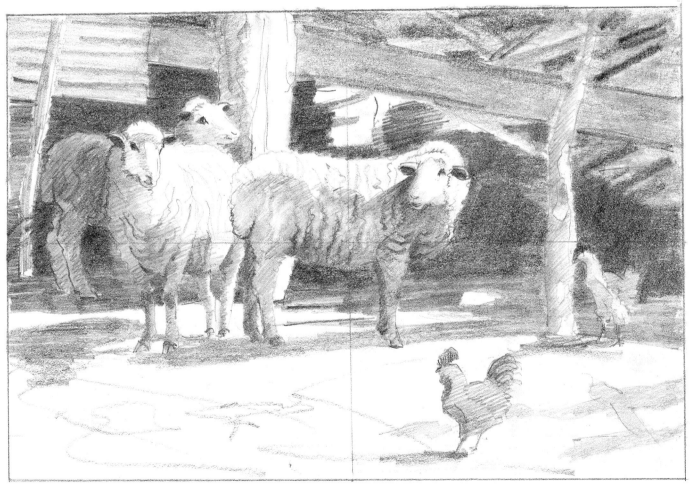

A sketch of the painting plan shows more of the detail in values.

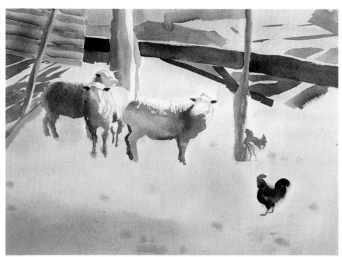

To get a feeling of warmth, I started this painting with an overall wash of yellow using a 2-inch wash brush. I painted around the sheep and increased the warmth and value of the color as I came into the foreground. Switching to a 1-inch flat brush, I used purple on the wooden posts and boards of the shed in the shadow to make them cooler. While the first wash was still wet, I added a warm wash of grayed yellow-orange to the shadow sides of the sheep and the chicken in the foreground. Then I let this stage dry.

The shadow sides of the sheep and chicken were added with a no. 8 round, wet on dry, creating a hard edge on the wool where the sunlight and shadow meet. This edge was painted in squiggly lines to indicate the texture and breaks of the wool. The chicken near the post was painted more definitely with hard edges. The posts, boards and corregated metal were also painted wet on dry for hard edges. Here some of the edges of the boards were dry brushed or dragged to make them look rough.

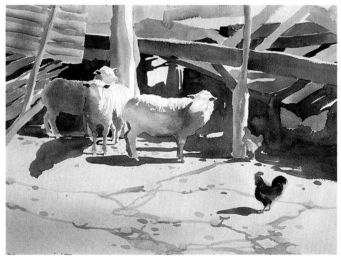

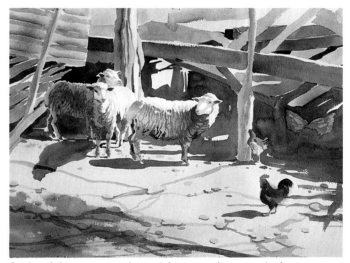

I drew two chickens back under the shed and painted them a grayed purple. Next I added the dark shadow area under the shed, painting around the chickens. To show the streaks and shafts of light, I painted the darks around them. I painted in some of the boards on the shed and some texture on the ground.

I painted the texture on the upright posts, plus more shadow texture on the ground. I felt the left side of the painting needed more darks to balance the right side, so I added the dark area in the foreground. Again, using squiggly lines to indicate breaks I painted the texture of the sheep's wool. Finally I painted the sheep's faces and added more feather texture to the chickens.

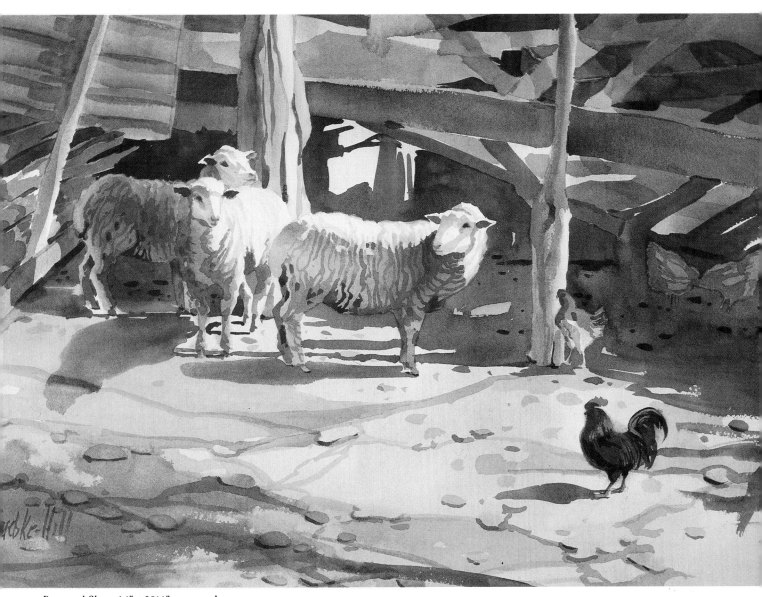

Barnyard Sheep, 14″ × 20¼″, watercolor

Chaco

Depicting a Dog's Breed, Coat and Character

Chaco is a bichon frise that belongs to our neighbors. The bichon frise is a breed of dog with a long, noble lineage. It originated in the Canary Islands in the fourteenth century as a cross between a Maltese and a poodle. The breed was in vogue in sixteenth-century Europe where it became a much sought-after lap dog for women. The dogs were frequently portrayed in paintings and portraits with their owners. The standard bichon is a small dog, standing between eight and twelve inches high at the shoulder, that is slightly longer than tall and pure white, with cream, apricot or gray on the ears and occasionally on the body. The hair of the coat is profuse, silky and loosely curled.

Chaco was about six months old when I painted him and still had all of his happy puppy vitality. Getting him to sit still was a major undertaking, but with the aid of some dog goodies, I could get him to sit for a few moments at time, even if only in my lap.

I knew it would be quite a challenge to put down Chaco's curly coat in paint, especially in watercolor. It had to be painted simply but made to look involved and complex, because that's how it really was. In addition, I wanted to describe Chaco's happy personality and great enthusiasm. I felt the painting should help also portray his ancient and distinguished lineage, so I chose a patterned background to help achieve the effect of elegance.

To emphasize his happiness and enthusiasm, I used light, warm, clear colors: Winsor yellow, permanent rose and ultramarine blue. The yellow and red colors are not strong in value, and each has a little blue that will slightly gray the other, yet they are still light, bright, warm colors when used in mixtures. The proximity of red and blue on the color wheel (each contains a bit of the other) makes for beautiful purple mixes.

An elongated horizontal format encompasses Chaco's whole body and gives me a chance to show some background design behind him.

I chose to use Winsor yellow, permanent rose and ultramarine blue. The first two colors are lighter in strength (value). This will help keep the painting in a higher key and give it a light, warm, happy feeling.

A pencil sketch of Chaco lets me familiarize myself with his anatomy and his fur.

After transferring a pencil sketch to watercolor paper, I applied the first wet wash with a 2-inch ox hair wash brush. I painted light yellows on his head and the background and soft oranges, grayed reds and purples on his body. Then I painted in the foreground with a warm orange color in a darker value and allowed the painting to dry.

I rewet the background and foreground with clear water using the 2-inch wash brush. Into this I put a red-purple wash, leaving some areas of the background and foreground with no wash. While that was still wet I put a pattern in the background using a no. 8 round brush.

Using the no. 8 round and no. 6 round for the more detailed areas, I painted in the curly hair on Chaco's body, face and whimsical ear. All I have done here is to paint around the areas that I want to be left lighter.

I put in the background pattern in the light areas. Also, I painted in Chaco's face, ear, collar, and more fur texture.

Chaco, 14½″ × 20½″, watercolor

To finish I lifted some areas that needed softening with a bristle brush, clear water, and a tissue for blotting. I also added a bit more fur texture in spots.

Desert Cottontail
Painting Multicolored Fur in Oils

I live on the outskirts of Tucson, Arizona, where the terrain is natural desert, so cottontail rabbits are part of my backyard fauna. There are four to six rabbits around the house at all times. They are as common in the landscape as cacti. If the coyotes remove a few of them, there are more young ones ready to replace them. At times it feels as though I'm living in the middle of their living room.

Painting cottontail rabbits presents the special problem of portraying their multicolored fur, which is their means of camouflage. If a rabbit is sitting out on the desert in the shade, it is virtually impossible to see. When it moves into the sunlight, it's easily seen because of its cast shadow. Here I decided to contrast the rabbit's body against the background for ease of visibility. Its head is partly dark against the light background and partly light against the

dark shadow. Its back is contrasted light against the dark background. You can understand why the rabbit would disappear if it hopped back out of the sunlight and into the shadow of the brush.

I chose a simple palette of cadmium yellow, burnt sienna, scarlet lake, ultramarine blue and white. These colors, when mixed, make nice oranges, good purples and grayed greens. The latter color, grayed green, is one I wanted to use in very small amounts. The shadows here in the desert tend toward blue and purple, a nice complement to the warm yellowed sunlight.

My husband, Tom, made a large, clear plastic box with one side screened for air. I have caught rabbits with a Have-a-Heart trap and put them in the box for short times in order to draw them and see them up close. A little food in the bottom

keeps the rabbit happy while it is posing for me. After a short drawing session, it is set free again.

In drawing cottontail rabbits, remember that their ears are about as long as their head. If you make the ears a lot longer it will turn into a jackrabbit. There are other differences between the bodies of these two rabbits that should be studied before drawing and painting them. The cottontail's body is a bean-shaped oval, the head is oblong, the front legs and feet are short, and the back legs and feet are longer. The back legs are folded into a springlike position, more so even than the cat's, which assists the rabbit in hopping and jumping.

I used my own mix of medium to thin the paints and obtain a smooth blending of colors to describe the softness of the fur.

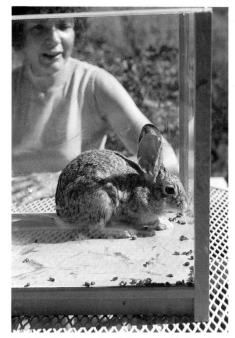

This is the clear plastic box my husband made. I can easily draw rabbits from life. It's so much easier to pick up details at this close range.

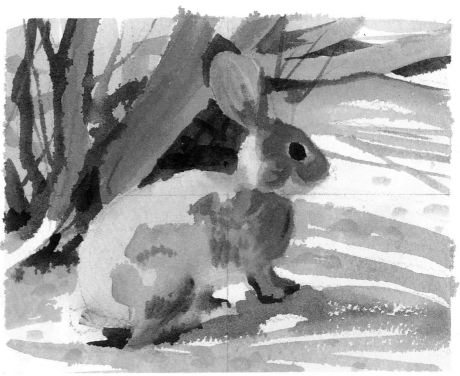

Using a no. 2 filbert bristle brush, i drew in the rabbit and background brush with burnt sienna only.

A thumbnail sketch shows my plan of contrasting the dark head against the light background, and the light back of the rabbit against the darker background.

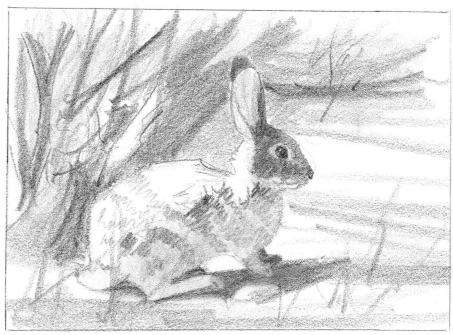

I did a more detailed pencil sketch to get the feeling of the underbrush and to familiarize myself with the anatomy of the rabbit.

A color sketch shows a simplified and subdued color scheme, which seemed appropriate for the subject.

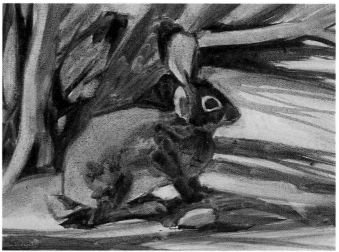

Switching to a no. 4 filbert bristle brush and mixing burnt sienna, ultramarine blue and scarlet lake, I painted this dark mix only in values. Here the mix was thinned with turpentine only.

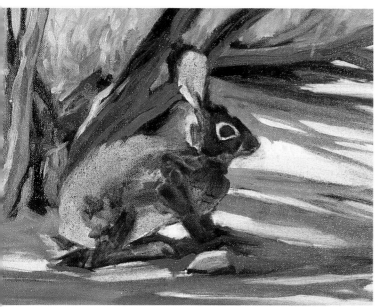

Using my own mixed medium, I painted over my value-only painting, adding color to the background, foreground and shadows. Much of the time we have purple shadows here in the Southwest, so I planned to complement the warm brush color and warm yellow ground color with purple shadows.

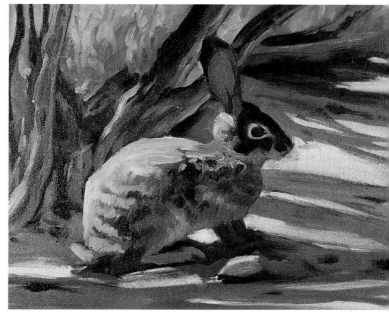

I used no. 2 and no. 4 filberts for most of the brushwork on the bunny's fur. Using my mixed medium with the oil colors kept the paints soft and buttery for easy application and easy blending of the fur. Since the fur had the same coloration as the ground and brush for its camouflage, the same colors were used in painting the fur. The only bright spots on the cottontail are the rufous coloring behind the neck and the orange-pink of the ears. When the sun hits those spots of color, they do become more noticeable.

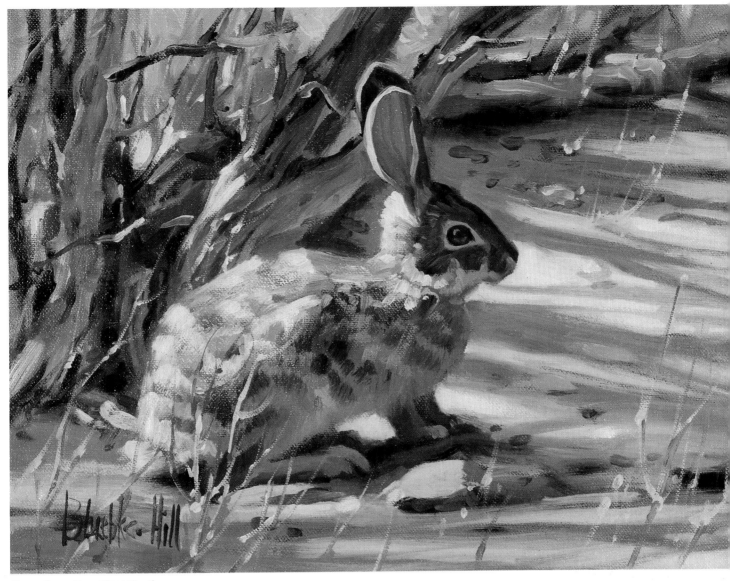

Desert Camouflage, 9″ × 12″, oil

For the finish, I lightened some of the shadows to a lighter grayed purple. I also lightened areas in the background brush and added spots of light. I added some cool reflected lights (grayed purple) to the shadow side of the bunny, and stroked warm lights into the fur on its back. Using a highliner brush I finished the ear and highlighted it on its edge. Then I softly outlined the eye and added the reflected light sparkle. Lastly I applied small weeds and twigs to finish the painting.

Barnyard Chickens
Portraying a Characteristic Gesture

Chickens are fun to paint. For one thing, there are so many different kinds, some with exotic plumage. A good place to see the fancier breeds is at a county or state fair. There are also people who raise some of the showier types as a hobby.

My grandmother raised chickens. When I lived on the farm as a small child it seemed she had hundreds. I always liked to help gather the eggs—to me it was like an Easter egg hunt. I remember being wary of the hens; most didn't want to be lifted and checked underneath for eggs, and I usually received a peck for my trouble. I can remember making a feinting motion with one hand, out of reach of the hen, to distract her attention, then reaching under her from the rear with the other. Regardless of their hazards, I never tired of the egg-gathering chores.

Pictured here are some quick sketches of chickens that I've made in a chicken yard much like my grandmother's. They have a whimsical feeling about them. The fun I had doing those sketches seems to show, although I wasn't conscious of trying to make them appear that way. When you are sketching these birds, note their comical behavior, pecking here, running there, usually with herky-jerky movements. They exhibit all sorts of colorful plumages,

and their combs sit on their heads like hats set at rakish angles.

When you are doing your gesture sketches, note the body shape of the chicken. It is mostly triangular, with a smaller triangle on top of that for a neck and a circular (or more oval-shaped) head, plus the bill. The shape of the tail depends on which type of chicken you are drawing. The tail of a rooster can be quite circular and graceful in feeling. This circular feature can be used in rhythms throughout the painting.

Usually, if you see one chicken, there are several more about. I made a composition using nine chickens since they seem so naturally gregarious. I sketched the different chickens I wanted to use in the painting and then moved them around into an interesting composition. Some would sit, some stand, and some move about to add interest. Placing the chickens in different positions, I made the strutting rooster and his wonderful tail the center of interest. Painting the rooster was pure fun. I knew he had to communicate elegance, importance and authority.

When chickens step forward their head and neck go forward, and when they shift their weight to that forward foot, the head and neck move backward or into a more upright position. You can recreate this jerky

feeling in your chickens if you place their head and forward foot closer together when they're taking a forward step and farther apart when they've shifted their weight. The placement of the feet, the tilt of the body, and the shifting of weight all have to make sense to look right.

I wanted to suggest a warm sunny day, late in the afternoon, with a predominance of yellows and oranges and just a small amount of cool complements. So I chose Winsor yellow, burnt sienna, alizarin crimson and phthalo blue plus white. Winsor yellow and alizarin crimson make nice grayed oranges because of the slight amount of blue in each. The yellow and orange mixtures also gray nicely with phthalo blue as it has some yellow in it. The result is a livelier grayed orange.

With all of this in mind my project was to suggest the late afternoon of a warm day in a typical barnyard, with chickens in positions that would describe them and their movements. I planned to use long cast shadows as well as colors to help suggest late afternoon.

Putting all of that into paint was a pleasurable challenge. Through the use of color, choice of animal subjects and placement—in this case with a high horizon line—I tried to achieve a creative piece.

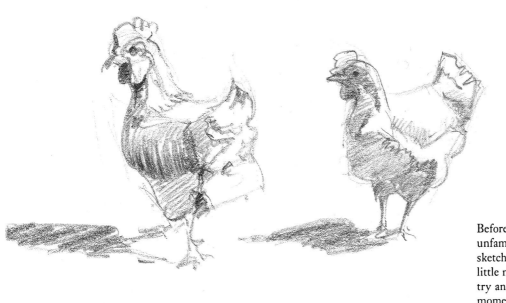

Before attempting a painting of somewhat unfamiliar animals like chickens I do quick sketches of them on the move—really just a little more than gesture sketches. It's fun to try and see what you can capture in a few moments with just a few strokes, and it will add a lot to your ability to correctly render these animals.

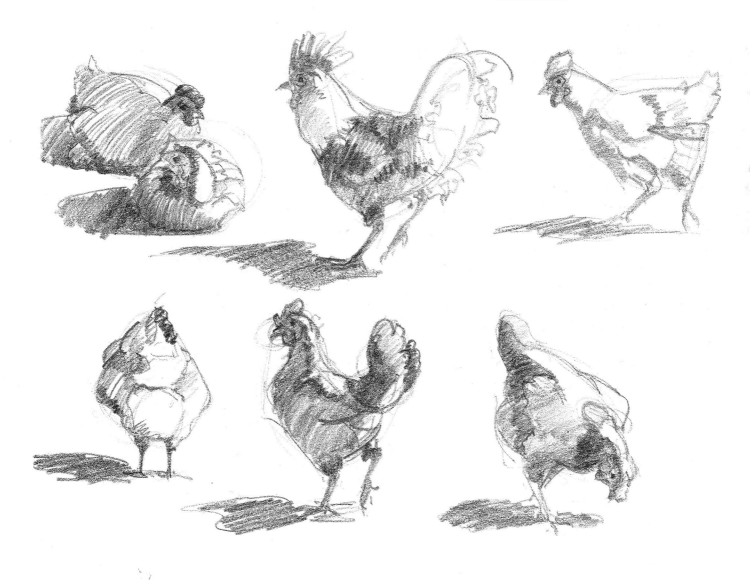

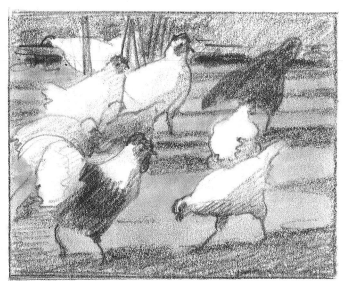

This value-only thumbnail is for composition purposes. I wanted the rooster to be the center of interest, so I started with him in the lower left. Then I placed the other chickens, trying to maintain movement throughout the painting.

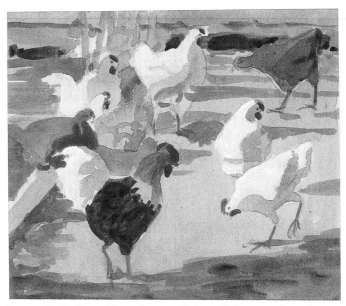

I wanted a feeling of late afternoon light so I chose a color palette of Winsor yellow, burnt sienna, alizarin crimson and phthalo blue.

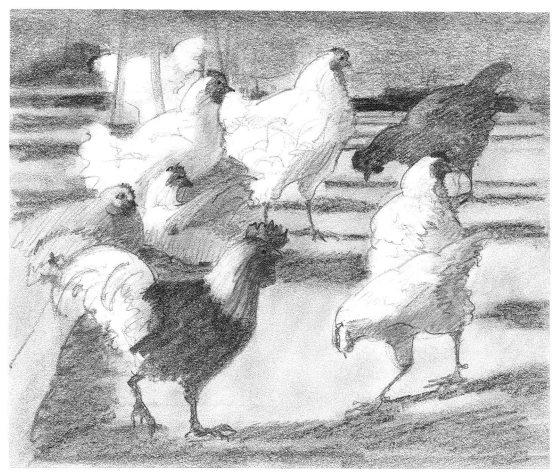

I did a more detailed value sketch to check the drawing and compositional placements. All of this preliminary work helps me familiarize myself with the chickens and achieve the results I have in mind.

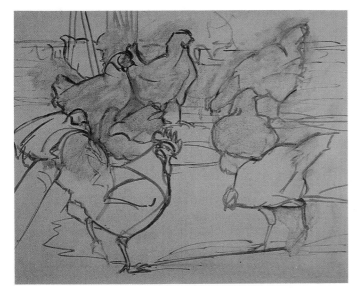

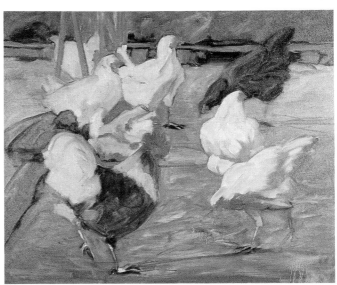

I started the painting with an overall coat of grayed yellow, then drew on top of that using a no. 2 filbert bristle brush. I made several corrections in putting the drawing down on the canvas. It's much easier to get the drawing right from the start than to make corrections halfway through the painting.

Starting out with my largest filbert brush (⅞-inch), I added the dark colors, the light colors in the white chickens, the barn and the hay in the background, and more color on the ground. The chickens I painted flat, just depicting their light and shadow sides. As I worked through the painting, from the first rough, loose layers of paint to the finer work of the finish, the size of the brushes I used diminished.

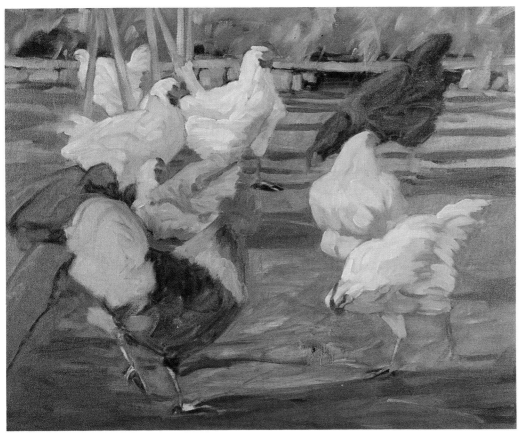

Some of the feather texture was added to the white chickens. Hay was added in the background, and the dark shadows were laid in. Everything was still being handled quite loosely.

The shadow area was modified with a cooler color, phthalo blue. The chickens' heads and feet were painted, as well as the rooster's feathers. Feather texture is easily indicated in oil. Each brushstroke can be a feather or group of feathers, but it must go in the direction you want the feathers to lie. Next, the sunlit area on the ground was lightened.

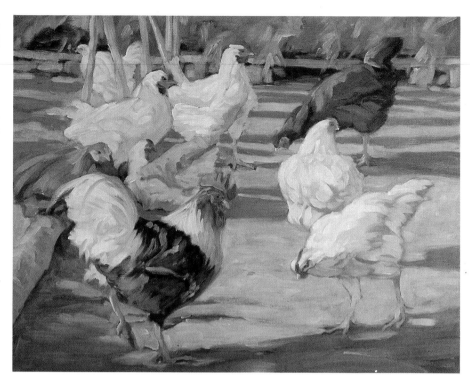

Note the brushstrokes in this close-up of the rooster's feather texture.

In this close-up of the rooster's head, note the shape of the bill and the tiny eye. The comb and wattle are much more elaborate on the rooster than on the hen. It's no wonder they strut.

Painting Animals Step by Step

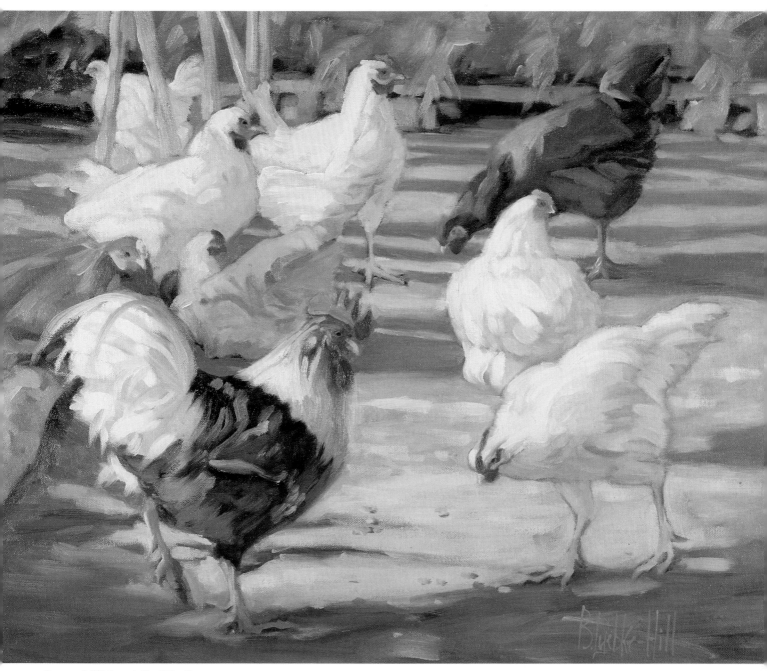

Barnyard Chickens, 16″ × 20″, oil

In the finish, more detail was added to the heads and feet. The highlighted feathers were lightened, and a few seeds were added on the ground.

Goats

Rendering Hair Texture in Sunlight

There are many places to find goats where I live. For example, my daughter-in-law used to raise them; the 4-H family who raised lop-eared bunnies also had goats; a not-too-distant neighbor raises goats.

The goats I painted here are being raised for milk, cheese and meat production. I could go right out into the enclosure with them and not feel threatened. They were used to being herded and accompanied by a person, so having someone about was acceptable to them. When you're looking for a subject to sketch, check the character of the goats with the farmer or herder, as some goats can be a problem. They are willful animals, sometimes cantankerous and sneaky, and very intelligent. Some like to butt you when your back is turned. My daughter-in-law says that they can be mischievous and unpredictable troublemakers who are usually not too affectionate.

Some make good pets, though, and are small, manageable animals for children's 4-H projects. They can forage on just about anything. Although goats are commonly depicted eating tin cans, that really doesn't happen. In fact, pet goats can be quite picky in their food choices.

I wanted to solve the problem of portraying the character of goats. I thought that a feeling of movement or force would create a dynamic impression. In the painting they seem to be moving, although they are just standing and pushing. Still, it gives a sense of motion, a sense that they are up to something! Also, I wanted to portray a warm, sunny atmosphere with brilliant light, so I decided to use crisp, dark silhouettes of their bodies against the light middleground and to play their light-value heads against the dark background.

Since the painting was going to be a fairly high-key painting, I chose cadmium yellow, scarlet lake, cobalt blue and manganese blue. All of these colors are of middle-value intensity, so I knew I would not have any deep darks. The dark I could mix with the red, yellow and blue would certainly be adequate for the painting. The yellow and red mix into a good green, which I would use sparingly in the painting. The red and blues (especially the red and manganese blue) when mixed make a lovely grayed purple. My plan was to make the painting predominantly orange and yellow, complemented with a smaller amount of the blues and purples.

The structure of goats is very similar to that of sheep, although goats are a little bit longer in the body. The rest of the proportions are very similar. The high point of a sheep's back is in the middle; in a goat, the high point is at the hip and shoulder, which are about level.

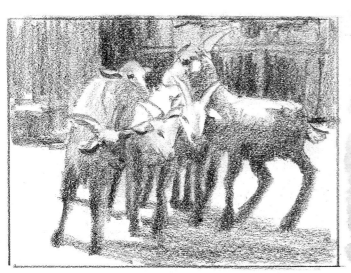

A small thumbnail shows the value plan.

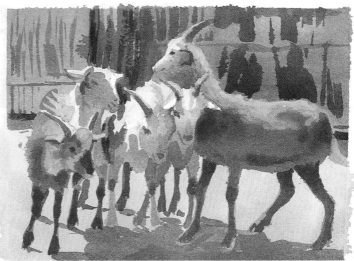

This is a color sketch using cadmium yellow, scarlet lake, cobalt blue and manganese blue. I liked the plan of silhouetting their legs, dark against the light background, and playing some of their heads as a light value against a darker background.

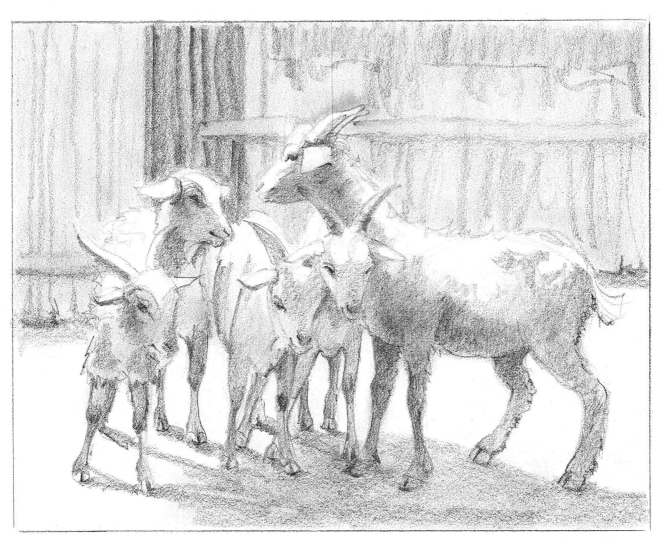

I drew this detailed sketch to become familiar with the structure of the goats. It also helped determine whether the forceful feeling of movement could be achieved.

I transferred the drawing onto watercolor paper and applied the first wet wash. I wet the paper with clear water, then using a 2-inch wash brush I brushed a light yellow all over the paper and drawing. While that was wet I went back into the wash with darker values for the goats, the background, and the shadows cast on the ground. I let this stage dry.

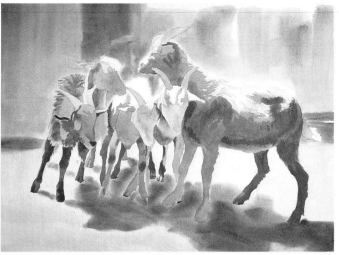

The first washes were painted on the goats with a 1-inch flat and a no. 8 round brush. A soft blending of colors in their faces was achieved by wet-in-wet painting.

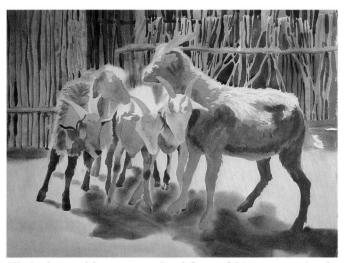

The background fences were painted. Some of this area was painted positively and some negatively (that is, I painted around something to depict it, instead of painting it directly).

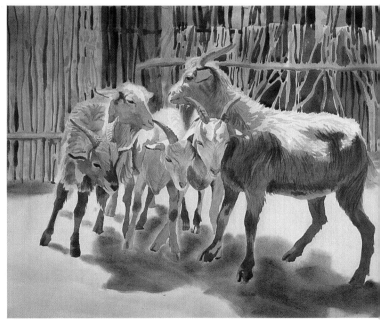

The coats of the goats were painted using no. 6 and no. 8 round brushes. Care was taken to indicate hair texture and length. Their faces, eyes, ears and noses were added. Their legs were silhouetted against the light background their faces and heads accentuated— light against a darker background.

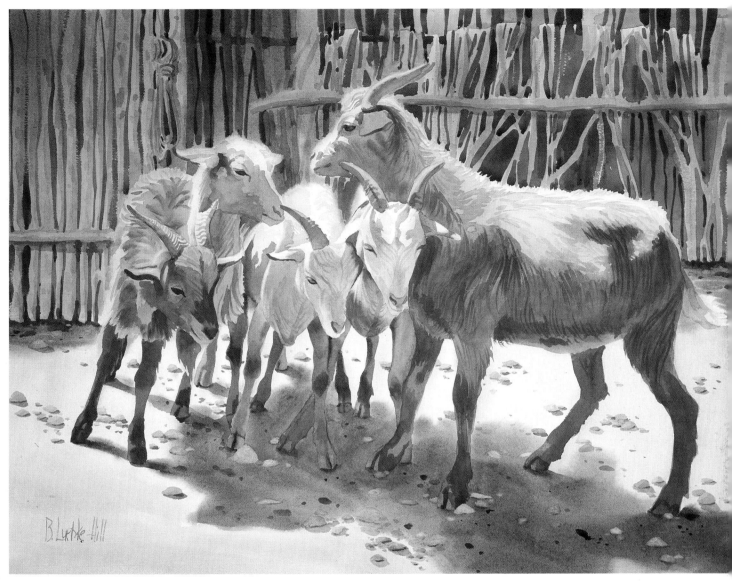

Goats, 22″ × 30″, watercolor

To finish, I painted in a rock texture on the ground. I painted some rocks positively and some negatively by lifting out and then painting back in. Then I painted another wash on the light area of the largest goat on the right. Last, I did more work on their legs and the shadows cast on the ground.

Ducks

Simplifying Feather Texture

Ducks can be portrayed in so many different ways. Ducks sleeping on land, ducks standing, walking, eating, flying or grooming—each subject can be made interesting. In this book I've talked about ducks on water, so I've concentrated more on painting feathers and reflections.

In this painting I wanted to emphasize feather texture without painting the feathers in detail. Generally, understatement is better than overstatement. In my sketch I noted all of the important forms the feathers make on the body. The head and neck do have angles and corners in their forms and their correct placement is important. The wings fold into the body, creating special indentations and bulges. It's helpful to hold a duck, extend its wings, and then watch them fold back into the body. Understanding the animals' structures and their functions is a big help in drawing them.

After sketching many ducks, I chose these two in somewhat opposing positions that create more tension and interest within the picture. Although, to some extent, the ducks pull apart from one another, the overlapping light areas of the ducks and the lights in the water give the feeling of a whole unit.

I wanted a color scheme different from the usual white-duck-on-blue-water. I also wanted an approaching dusk or last-light feeling. The colors I chose were Winsor yellow, alizarin crimson, burnt sienna, ultramarine blue and white.

A small thumbnail sketch shows the values and the opposing positions of the two ducks.

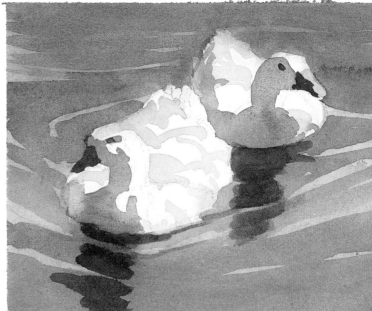

In this color sketch I wanted to suggest the low light of early evening.

In a more detailed sketch, I familiarized myself with the ducks and their feather texture. The ducks also had to appear to be sitting down into the water and be in perspective; this front view is a little more difficult to portray.

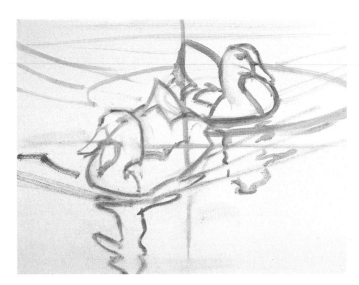

Using the squaring off lines to help guide the placement of the ducks, I transferred the simple drawing to the canvas with a no. 2 filbert bristle brush and burnt sienna.

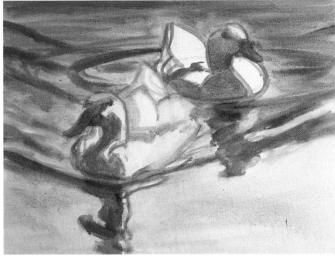

The values were painted using burnt sienna only. The water was graded dark at the top to lighter at the bottom to help the water lie down in perspective.

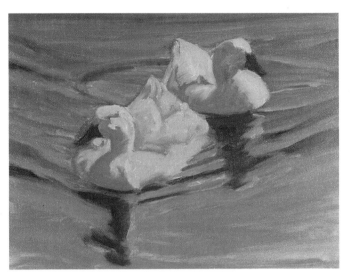

Using a no. 4 filbert bristle brush, I added the first color. I painted the light areas of the ducks yellow and their shadows blue, indicating just the creases of their feathers. I kept the water liquid by smoothing and blending the edges of the ripples. I used more hard edge in the reflections in the water.

Another layer of color was added to the water with more smoothing and blending for a liquid look. The feather texture was added loosely using strokes of partially mixed paint and a no. 2 filbert bristle brush. Each stroke was a feather or group of feathers. More color and texture were added in the shadow areas on the ducks, and more yellow representing reflected light was added to the water. The eyes, bills and heads were finished.

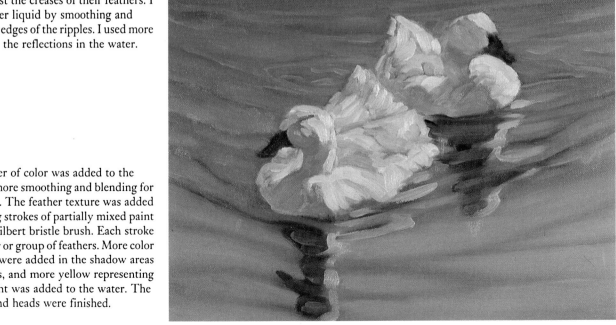

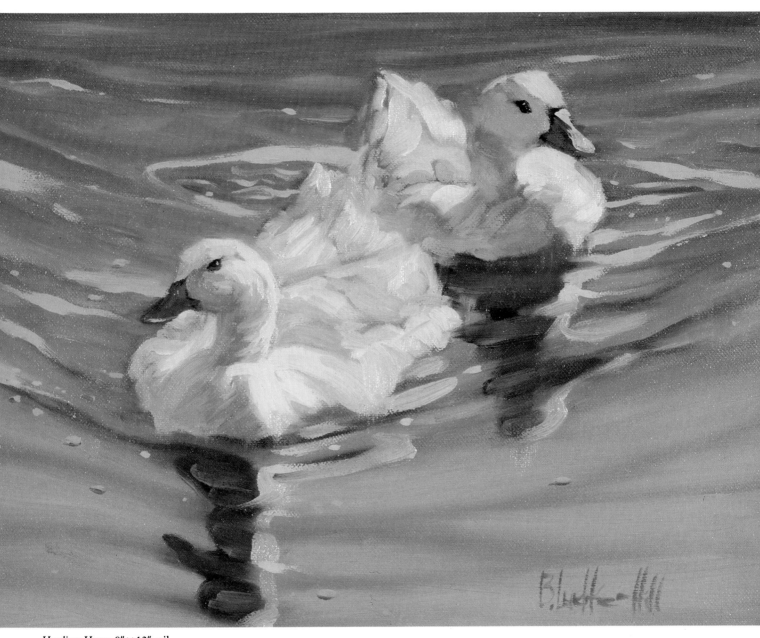

Heading Home, 9" × 12", oil

In the final painting, note the blue in the shadow area representing light reflected into the shadow. Also note the warm light reflected from the water onto the underside of the rear duck's chin and neck area. Note the darker core of the shadow with its soft edge. The feathers have been handled very simply. Here large strokes of paint represent groups of feathers.

Brandy

Painting Colorful Fur in Evening Light

I met Brandy, a beautiful chocolate Labrador retriever, on a hot fall day. The sun was beginning to throw the long shadows of early evening, but the air was staying very warm. Brandy was a little wary of me, a stranger. I wanted to take some photos of him, so I brought my camera, plus a large sheet of white foamcore board to bounce light into his shadow side. The camera didn't bother him, but the foamcore board made him a little uneasy. He kept looking at the board, checking out what it was doing. Because the day was hot, a sober, mouth-closed shot of him was out of the question, as he needed to pant. I felt the heat almost as much as he did.

Brandy is a lively, alert dog, who is eager to please. He made a half-hearted attempt at playing ball, but soon let me know it was my turn to go after the ball—it was too hot for him. He tolerated a photo session for about fifteen minutes, sitting, standing and lying. Then he trotted to the pool, jumped in, climbed out and sat down in the shade. His message was clear: The photo session was over.

I thought of a red painting when I first saw this dog. The problem I wanted to solve was to paint a predominantly red painting using Brandy's reddish coat as my guide. I knew the warms would require some cools for relief.

Brandy's coat is a purple-red color. The warm oranges of his coat appear when his hair is in shadow, or when a hair tract changes direction, or when part of is form is not reflecting light directly. This cool and warm red combination gave me a great opportunity to use variations of oranges and reds as the predominant colors, complemented with a cooler yellow-green. I chose Winsor yellow, scarlet lake, alizarin crimson, phthalo blue and white. Both the scarlet lake and alizarin crimson give me a grayed purple when mixed with phthalo blue because of the yellow in the blue and in the scarlet lake. The Winsor yellow and scarlet lake produce clear oranges, and the minute amount of blue in the cool yellow does not gray the color enough to cancel the brightness. The small amount of yellow-green I intended to use would be bright and clear when mixed with Winsor yellow and phthalo blue.

I chose a mouth-open, smiling attitude, as I felt this would be an additional challenge. It's much more difficult to paint an open mouth than a closed mouth on a dog—or any other animal, for that matter.

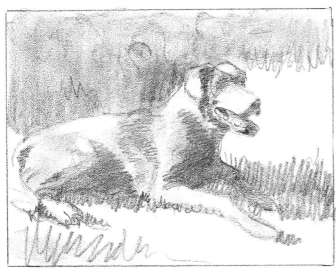

In this thumbnail sketch of Brandy, his head is placed in the upper right quadrant of the picture plane. His tail is cropped slightly.

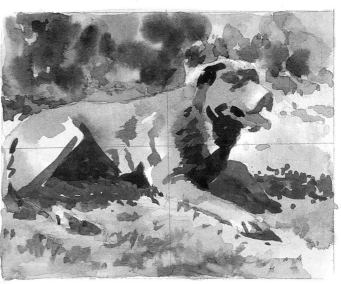

A color sketch strives for a "hot" feeling for a red dog.

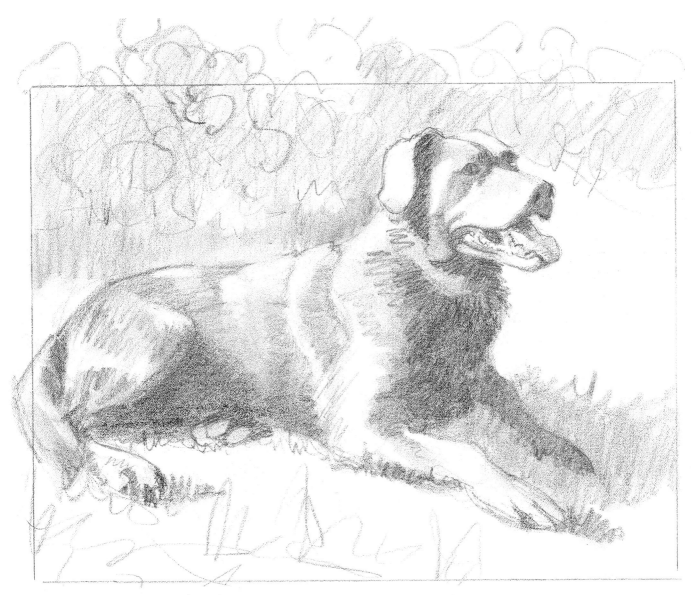

A more detailed sketch of Brandy lets me familiarize myself with his anatomy and position.

I drew Brandy on the canvas with a ¼-inch flat bristle brush. This drawing was done with a mixture of Winsor yellow and phthalo blue. I felt that allowing parts of the original drawing to show through in places in the final painting would help complement the reds.

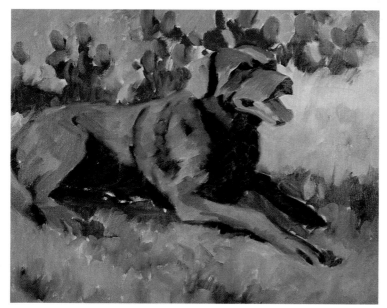

The dark stains were painted, then the first colors were painted on Brandy. I added the background cactus and foreground grass. I wanted only a suggestion of cactus, so the background would be subdued later. In reality Brandy had been lying on green grass, but for better color harmony I changed it to oranges with a touch of cools for complement and maintained a predominance of reds and oranges.

The background was subdued further, pulling the colors together. I didn't want the background to detract from the subject, Brandy. More darks were added to the foreground.

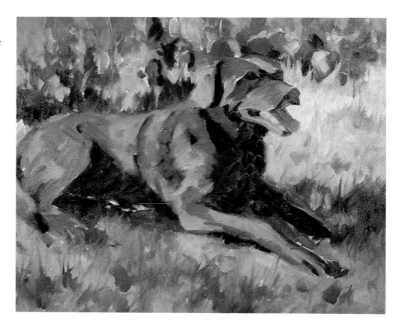

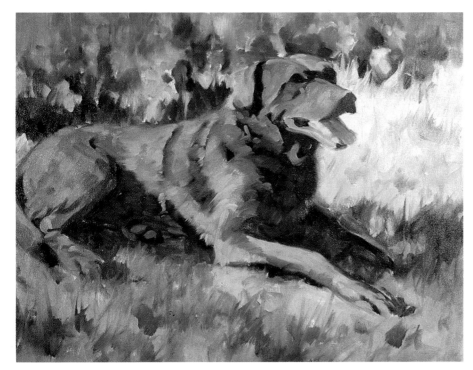

I went back into the first dark stain on Brandy with deep oranges and reds. I painted the areas in shadow a warm red, the areas in light a cool purple red. I let parts of his body remain in the warm orange reds, depending on the hair's direction and the reflection of light from that area of hair. The open mouth is painted in simple shapes. A purple shape depicts the tongue; a light red, the teeth; and a dark brown represents the depths of the mouth.

The detail in the eyes, nose and mouth was painted. Then more of the highlighted areas of his coat were painted, with brushstrokes following the direction of the hair growth. The background was darkened so there would be less activity behind Brandy to distract the viewer's attention. More detail was painted in the foreground grass area. The light area of the tongue is painted a light red with an orange stroke of color to the lower tip. A dark subdued red is painted into the depths of the mouth to indicate gums. The teeth in shadow are painted with strokes of yellow and painted almost white in the light. The light paint indicates the glisten of moisture.

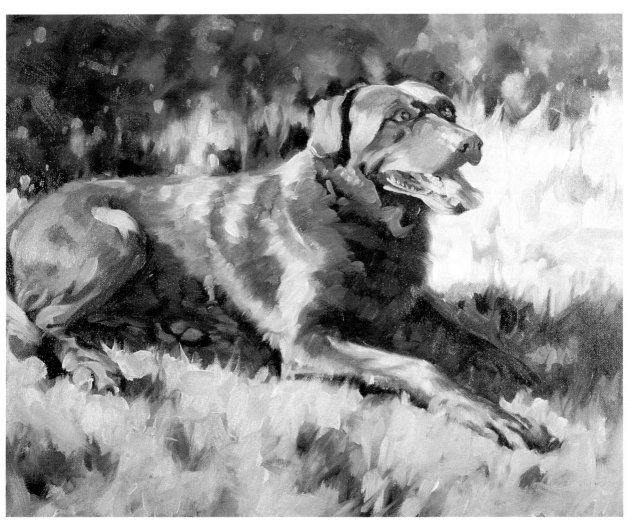

Brandy, 16″ × 20″, oil

Last, more work was done on the face and mouth, and the dog's left eye was subdued. Final adjustments were made on the background and foreground.

Man has always loved to draw animals. The drawing of animals dates back to the work of early man in caves. Every culture has depicted animals important to the people of that time. Artists have portrayed the delicacy of birds, the ferocity of lions and tigers, the strength of bulls, the fleetness of horses, the friendliness of dogs, and on and on. Man seems, in fact, to have a built-in love for animals. As long as animals are here with us, artists will want to draw and paint them.

This book has tried to show you how I paint animals in oil and watercolor. But don't let my example limit the directions you find to go with your work. A whole world of opportunities is open to you. Concentrate on drawing and painting the animals living around you; you'll find a ready and inexpensive source of live models. Take time to go outside to find your subject or draw your pets inside, but always draw from life. The more time you spend drawing animals, the more knowledge you will gain before you begin painting; this preparatory work makes the painting process go smoothly.

It is not easy to learn to draw animals. You must learn the characteristics that make each one unique. However, as you practice drawing animals, you'll discover great similarities in their structures, even between very different animals.

Paint what you like. Learn what subjects or settings make you want to draw and paint. And do your own work; don't trace, copy or emulate someone else. When you do that, you never have the feeling that your work totally belongs to you. You will, of course, start out with some degree of ability — the challenge is to improve. All it takes is an interest in painting, a love of animals, and a lot of dedicated work. Paint in the manner that feels best to you, always striving to do better — and that means being critical of your own work. When you find yourself in a comfortable niche, take a second look. Are you improving? Paint, paint, paint. The more time you spend drawing and painting, the greater the rewards you'll reap.

Spend time in museums and galleries, too, looking at paintings and drawings of animals that others have done. You are developing your own taste in art and creativity. The more you see, the more you refine your own taste.

Now, it's your turn. I hope I've inspired you to take up your pencil and brushes. I send you all my best wishes.

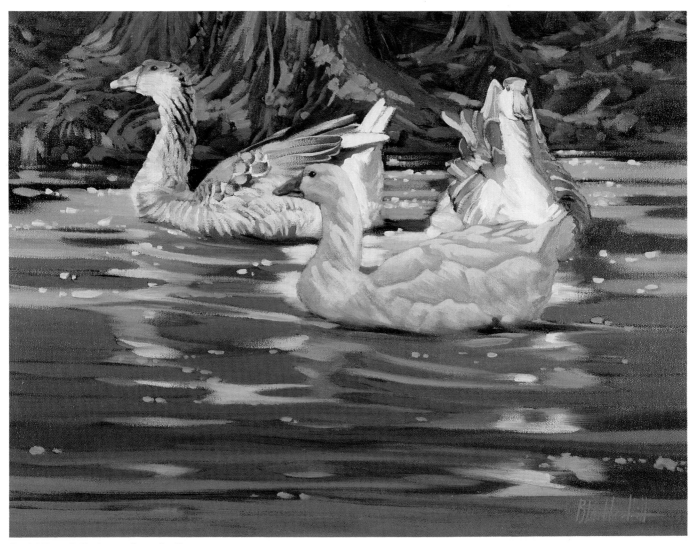

Dark Water Reflections, 18″ × 24″, oil